How to Talk to CHILDREN

ABOUT

WORLD ART

To Natacha
And to Françoise, Joseph and Éric.
With thanks to everyone, whether a child or an adult, who has come on
a museum tour with me: your questions have encouraged me to find out
more about the cultures of the world.

How to Talk to Children about World Art

Originally published in France as
Comment parler des arts premiers aux enfants: Afrique, Amériques, Asie et Océanie
by Le baron perché 2006

First published in the English language by
Frances Lincoln Limited
4 Torriano Mews
Torriano Avenue
London NW5 2RZ
www.franceslincoln.com

Translation by Phoebe Dunn
copyright © Frances Lincoln Limited 2010

A catalogue record for this book is available from the British Library.

978-0-7112-3091-0

Printed and bound in China

1 2 3 4 5 6 7 8 9

How to ? Talk to CHILDREN

ABOUT WORLD ART

Isabelle Glorieux-Desouche

F

FRANCES LINCOLN LIMITED
PUBLISHERS

CONTENTS

174 Further Information

FOREWORD

In recent years art from Africa, Asia, the Americas and Oceania has become increasingly popular. More and more beautiful books about world art are appearing and they are selling to an ever broadening readership. Not a year goes by without some significant new exhibition opening and museums are refreshing the way they present their global collections and attracting ever more visitors. The 2006 opening of the Musée du Quai Branly in Paris and the 2010 redevelopment of the Pitt Rivers Museum in Oxford are testament to this international trend – world art is finally receiving the recognition it deserves.

Nevertheless, it can be challenging to look at art from civilizations far removed from our own. Without any shared cultural, mythological or religious reference points to connect with, it is easy to feel like you don't understand and assume that you'd better not even try to talk about it with children.

The aim of this book is to help. Whether you are an old hand or a relative newcomer to world art this book should provide new ideas and advice for helping children get to grips with art from all over the globe. The aim is to make approaching world art simpler for everyone whilst casting a critical eye over preconceived ideas.

To prepare the reader for anything kids might ask, we have provided answers to some of the more obvious children's questions, as well as responses to more unusual comments. The idea is that if you have just a little basic knowledge (and without having read hundreds of books on the subject) it is possible to appreciate the beauty and originality of any world art you may encounter – be that an African mask or an Asian puppet.

This isn't an in-depth study, and neither can this book claim to be comprehensive. Selecting items to feature was a frustrating process – doing justice to the variety of art from the four corners of the earth is a tall order with just thirty objects. We could be neither too detailed nor could we be too encyclopaedic but we have included as much ethnological and historical information as possible to complement the aesthetic approach to the featured artefacts. If this book makes you want to learn more it will have done its job.

RE-VIEWED:
THE WAY WE LOOK AT ART
IN THE WEST HAS CHANGED

How did exotic works of art reach the West?

Westerners have dreamt about the mythical wealth of far off lands since before the first European explorers set out on their voyages of discovery. Now even those voyagers' names are evocative of the lands they explored and the treasures they brought home: names such as Marco Polo (1271, Asia), Christopher Columbus (1492, America) and Vasco da Gama (1497, the sea route to India via the Cape of Good Hope). Of course, since ancient times trade had brought such rarities as African ivory and Asian silks to Europe. But from the fifteenth century western explorers were ordered by their patrons to bring back as many exotic objects (natural or locally made) as possible, as evidence of the wealth of those distant continents. They also brought back humans from the lands they explored – to be displayed as specimens at the courts of Europe.

As they searched for a sea route to India, the Portuguese travelled along the coast of Africa, but they brought relatively few typically African artefacts back home. Since antiquity African ivory had been highly prized in Europe but they preferred to commission sculptures in the Portuguese style from local African craftsmen. These ivories – now known as Afro-Portuguese – combine Portuguese iconography with African expertise.

During the Renaissance European royals were keen collectors of Chinese and Indian porcelain and jade. Then from the eighteenth century onwards, artefacts from Oceania started to reach Europe – largely as a result of barter conducted during scientific expeditions. Scientists' drawings of the time showed the peoples they encountered, complete with clothes and jewellery, though these studies of the exotic were of secondary importance to the zoological or botanical purposes of the voyages.

Almost everywhere they went, missionaries simply burned works of art they believed to be ungodly. If any were preserved it was more often to provide evidence of depravity than as a result of any historical interest. But the missionaries were also the first to observe, learn and document the languages and customs of those they encountered – particularly in America. Colonists, explorers, sailors, archaeologists, ethnographers, travellers, merchants, doctors and businessmen all stole, bought or exchanged souvenirs, trophies and artefacts. Then between 1870 and 1880 there was a growing awareness that the cultures which were being 'civilized' by the white man would soon disappear completely. So missions

were organized to collect evidence of these cultures – with little thought (until the 1920s and 1930s) for the responses of the people whose heritage was being removed.

How were these exotic works viewed by western audiences at the time?

Poles apart from the Greco-Roman tradition, the art of 'savages' was originally rejected on both aesthetic and moral grounds. Collecting exotic artefacts often meant displaying the savagery of their creators and providing justification for their colonization and their conversion to civilization and progress. However, right up until the twentieth century exotic objects from distant countries were, above all, collected out of curiosity for their very *otherness*; out of fascination for the expertise evident in hitherto unknown techniques like the feather work of the United States; or out of sheer astonishment at the use of precious materials such as ivory and gold. Whilst many expedition reports praised the indigenous architecture and compared certain towns to western cities (Cortés's men referred to Venice in their descriptions of the Aztec capital Tenochtitlán) their artefacts, judged by the aesthetics of the time to be crudely made, were often offered as proof of the backwardness of their peoples (Bougainville for example wrote of the 'badly made and ill-proportioned figures' of Tahiti). Collecting was common, but it was also fashionable to adapt items to suit European taste – decorative elements such as feathers or fabric were often removed from masks for example, leaving them denuded of their headdresses or even their clothes. But since at the time these objects were not seen as works of art, very few of them remain today. For example though thousands of items were brought back from the Americas during the sixteenth and seventeenth centuries only a few hundred have survived.

How and where were they displayed?

As public museums didn't exist at the time, the first items brought back from voyages of discovery were kept in 'cabinets of curiosities' or 'wonder-rooms'. They would house both extraordinary natural objects such as shells and stuffed animals and man-made items known as 'artificial curios'.
As museums evolved, the distinction between natural objects and 'artificial curios'

was increasingly made. In their own way the latter became objects of scientific interest since they allowed an evaluation of their creators' level of development. Some found their way into art collections, but from 1820 there began to be calls for dedicated museums to house them. Gradually these objects began to appear in specially created museums of ethnography – in 1856 in Berlin, 1884 in Oxford and 1887 in Paris. In Washington DC, the Smithsonian Institution was founded in 1846. The National Museum of the American Indian (one of its member museums) wasn't created until 1989, although the NMAI's current holdings have their origin in the Heye Foundation of New York City, opened in 1922. These museums led efforts to understand distant societies by analysing how they organized themselves and by studying what would henceforth be considered 'ethnographic specimens'. These 'primitive' societies were also compared to ancient western civilizations in an attempt to establish a hierarchy of progress. In the twentieth century these objects began to be seen less as evidence of exotic barbarism or of human development but as essential clues in understanding societies from an ethnographic perspective – as evidence of cultures which we now see were valid and vibrant in their own right. From this point on expeditions started to be mounted with the explicit aim of gathering ethnographical objects and information – for example from 1931–33 the Paris Musée du Trocadero (formerly the Museum of Man) sponsored ethnographer Marcel Griaule's cross-Africa expedition from Dakar to Djibouti. Though the status of the objects collected remained 'scientific' during the first half of the twentieth century, attitudes were beginning to change and they began to be seen as works of art.

How did the West view the people who had created these works?

Many westerners had a very prejudiced view. The peoples responsible for world art were often depicted as savages or as barbarous backward cannibals in need of civilizing. In the nineteenth century they weren't only seen as savages but as 'primitives' – albeit of the modern variety – and they were compared with our ancestors, prehistoric man. It was widely thought that these people represented the missing link between 'us' (western, civilized man) and 'our ancestors' (prehistoric man) since they appeared to live in a similar way to our ancestors in a kind of Stone Age. Despite centuries of development and philosophy about 'the other' there was still a sense of superiority amongst most

Europeans – some of whom went so far as to question whether certain of these peoples were even human.

American Indians – At the Valladolid debate held in 1550–51 the Spanish discussed the Native American Indians' humanity, aiming to decide whether they were indeed free men, and God's creatures. Bishop Bartholomé de Las Casas argued that they were and – contrary to popular opinion of the time – were not therefore destined to be enslaved. Nevertheless the need for manual labour to exploit the new world was unrelenting and in due course African slaves began to replace American Indians. Thus began the slave trade between Africa, Europe and America.

Africans – Africans were so poorly thought of that they were immediately seen as potential slaves. Between the sixteenth and the nineteenth centuries about 11 million Africans were deported to the Americas in chains. In the eighteenth century, with the slave trade at its peak, the enlightenment philosopher Montesquieu parodied the thinking of the time saying, 'It is hardly to be believed that God, who is a wise Being, should place a soul, especially a good soul, in such a thoroughly black body.'

Oceanians – Oceanians were generally seen by Europeans as one of two archetypes – neither particularly flattering. First was the Polynesian woman or *vahine*, an exotic siren leading sailors astray and occassionally a symbol of paradise lost. Secondly there was the Melanesian cannibal, a poster boy for savagery and barbarism. The myth of the noble savage developed by Rousseau in the eighteenth century gave way to the image of the savage in need of civilizing. During the nineteenth century the Australian aboriginals were judged to be the most primitive of all the Oceanian people due to the simplicity of their tools. In fact, the boomerang was the sole reason that they weren't consigned to the category of animals. The 1881 *Journal des Voyages* wondered 'How can it be that the natives of Australia have managed to conceive of, create and master such a perfect weapon?'

Are there different human races?

No, there is only one human race. In the nineteenth century some evolutionists took their cue from Darwin and argued for the existence of several human races, some of which were superior to others. These theories were somewhat supported

by the science of the time, which studied man like any other creature, animal or plant, classifying men from the least to the most evolved. Even today there is a tendency to perceive the differences between people in terms of long discredited concepts. Scientific research in the shape of genetics and palaeontology has shown definitively that there are no sub-divisions to the human race; all people come from the same origin (*homo sapiens sapiens*). Modern man (that is to say post *homo sapiens*) appeared one or two hundred thousand years ago, probably in East Africa, whereas hominids existed for 8 or 9 million years before that. The physical differences which led to the belief in different human races are in fact superficial – there is only one human body. We all have the same number of genes so it's impossible to tell someone's region of origin by looking at their genetic material alone. The differences between people are really only a matter of the outer envelope – the diversity of our appearance (eye colour, skin or hair colour, shape and measurements of the body, facial features and hair thickness, for example) is all the result of adaptations to climate and the environment over tens of thousands of years. The long history of migrations and intermarriage explains the differences and similarities between populations living at the same latitudes. Contrary to what was once believed there are no such things as 'black genes', 'white genes' or 'yellow genes'.

What kind of relationship did the West have with these distant lands?

The impetus for early exploration was primarily economic, religious, scientific and political rather than philanthropic. Originally there was the search for countries full of precious raw materials, then there was the challenge of mapping the world, which of course led to the recognition of new territories which could be colonized.

Colonialism – From the fifteenth century onwards a huge European expansion took place overseas. In every continent, colonies were established by the likes of Portugal, Spain, France, Britain, Holland, Germany, Italy and Belgium. Though their initial goal was to exploit the natural wealth of these new territories, during the nineteenth century (when expansionism was at its height) the colonial powers used their economic and political dominance to 'favourably repopulate' and 'civilize' these distant lands.

Evangelism – Evangelism often went hand in hand with colonialism and tended to favour cultural integration. The role of the missionary was primarily to affirm the power of Christian nations on earth through the teachings of Jesus Christ. During the nineteenth century the Protestant and Catholic churches were actively engaged in education, health and the fight against slavery. Today's spread of Christianity across the world is testament to that evangelism.

Human Zoos – During the nineteenth century, human zoos started to appear in the West. Back then it was almost as rare to come across a person with different skin colour as it was to encounter an exotic animal. Westerners could experience 'the other' in the form of caged human beings. Later, people were exhibited at universal or colonial exhibitions or presented in mocked-up villages often showcasing the savagery of the indigenous people with stage-managed cannibalism rituals or bloody battles bearing no resemblance to reality. 'The other' remained subjugated by being reduced to the status of animals. At the 1931 Paris Exposition Coloniale, for instance, one hundred and eleven Kanaks from New Caledonia were on display (a few were subsequently swapped for crocodiles with the Museum of Hamburg). They were recruited and displayed as 'cannibals' but most of them had in fact already converted to Christianity and even spoke French! These dramatized encounters with foreigners in the role of dangerous monsters informed much of the public racism of the time and indeed many modern day stereotypes. One hangover is the difficulty that many still have in seeing the beauty in 'primitive art'.

Why were these people thought not to have developed? Were there really societies that didn't evolve?

There was an incorrect but nevertheless long-held belief that these societies had never changed their ways of life and would be happy to keep on reproducing the same old objects until the end of time. It was clearly untrue; pointing out the simplicity of techniques does not prove their inferiority. And whilst there is a lack of documentation about the technology of everyday objects (bows, harpoons etc.) they are nonetheless highly sophisticated. Just like western cultures, non-European societies were constantly evolving and changing; their history and traditions, and their social and economic systems developed over the course of many migratory fluctuations in population. Their ways of life adapted to

technical shocks and philosophical changes (such as the arrival of new religions like Hinduism, Islam and Christianity) and to political shifts (such as colonization or independence) and to contact with other peoples (through war and trade but also tourism, which could drive changes such as the reorganization of traditional festivals). These changes all had an impact on indigenous art which continued to evolve from one century to the next. Unfortunately, the subtle variations were not always noticed by the first western conquerors, or by later researchers, and more recently by western tourists.

Societies and History – For a long time non-European people were seen as backward, and akin to prehistoric man. As far as most western historians were concerned, societies that had mastered writing were able to ensure that they made the transition into history. Those that had not were believed to be stagnating, caught in a quasi-prehistoric state.

The idea that civilizations without writing have no history is of course absurd – even though events and dates were not noted down, societies may nevertheless have attached significance to them. In those cases it just means that the transmission of history was simply done differently – by way of an oral tradition. Increasingly the subject of specialist study, oral traditions are just a different way of remembering and passing on historical and cultural information and are as rich and fascinating as any written tradition.

Towards the end of the nineteenth century, world art starts to be seen as demonstrating true artistic expression

Objects from distant cultures begun to be seen less as 'ethnological specimens' and more as samples of their originators' culture. Commentators started to use terms which had previously been reserved for the West such as 'civilization', 'art' and 'artistic expression'. Among them were the writer and modern art historian Carl Einstein, anthropologists Franz Boas and Leo Frobenius, the ethnographer and art historian Hans Himmelheber and the collector and art dealer Paul Guillaume. These foreign societies were no longer compared to one another, but studied in their own right. The objects were of interest in and of themselves and not just because of how they were used or what they signified ethnologically. During the 1930s museums became places for the study and teaching of art and civilizations.

Back in 1912 the poet Guillaume Apollinaire described a sculpture from Benin he had seen in the Musée du Trocadéro as 'a pearl' saying 'The negro creator was clearly an artist'. Coming as it did in an era when Africans – still referred to as 'negroes' – were thought by many to be incapable of artistic expression, this evaluation marks Apollinaire as one of the first to demonstrate true respect for the artists as individuals. Until then, artists had been considered anonymous and their creations seen as collective.

In 1888 Paul Gauguin wrote 'I love Brittany. There is something wild and primitive about it'. The search for the wild and the primitive took him to Tahiti in 1891 and then to the Marquesas Islands. He opened the way for the Primitivist movement in France (with artists aiming to refresh their own art through the study of world art).

In 1904 German Expressionists discovered exotic (notably Oceanian) art in museums. The painters Emil Nolde and Max Pechstein were among the first to visit the countries whose art they so admired by travelling to the Pacific (then known as the South Seas). In France the Fauvist and Cubist artists (Maurice de Vlaminck, Henri Matisse, André Derain, Pablo Picasso and Georges Braque) threw off the shackles of western academic tradition and became avid collectors of 'Negro Art' (particularly African). This was revolutionary as they were interested in artefacts not for their provenance or their function but above all for their artistry. These objects were a springboard for artists of the time to free themselves from western traditions. They found that world art spoke to their own ambitions (representing reality without copying it) and they recognized in the non-figurative art of the exotic an opposition to what they themselves were trying to avoid; the all powerful aesthetic canon. They admired the creativity, expressiveness, the sense of volume, simplicity and rhythm, the distortions of the human face which conveyed emotion without having to imitate reality. The Surrealists were fascinated by works which brought together disparate objects. In their turn, Man Ray, Max Ernst, André Breton and Alberto Giacometti made their own contributions to the recognition of the art of Oceania and the Americas. The first half of the twentieth century is certainly marked by artists of all kinds (Constantin Brancusi, Fernand Léger, Alberto Magnelli, Henry Moore, Roberto Matta, Jackson Pollock) becoming interested in world art.

As attitudes towards 'the other' became more open and more respectful of differences, so did collectors and curators, as well as the viewing public, begin to be less discriminatory in their appreciation of world art.

How and where is world art displayed today?

Today, world art tends to be displayed in ethnological museums, in galleries and in museums of civilization which are a kind of hybrid. Whether an object is displayed as a work of art or as an ethnological object will depend on the kind of institution in which it is displayed.

Ethnological museums tend towards displays with a technical focus. The emphasis is on seeking an object's meaning where the object itself is seen as a piece of evidence, capturing and representing some truth about the diversity and complexity of the society from which it came. The ambition of ethnological museums is to respect those societies by presenting their objects, highlighting how they were used without changing them or in any way diminishing their significance. For example, a mask which is typical to a particular region or people might be worn by a mannequin in a dancer's costume, or accompanied by photos illustrating how that type of mask is used. The display must above all focus on the mask's function without overlooking its formal and artistic aspects.

Galleries focus on the beauty of the objects they display. By definition the objects displayed in a gallery are no longer in use, so no attempts are made to build contextual displays. Instead, galleries will ensure they promote the quality of the craftsmanship and artistry and allow the viewer to admire the object at their leisure. The fact that objects with the same function can differ in form illustrates the importance that their creators placed on how they looked. So in the case of a mask, attention might be drawn to what makes it exceptional by presenting it alone behind glass. In these cases it is visual enjoyment which is of the utmost importance and historical or ethnographical information takes second place.

But any kind of museum presentation has its drawbacks. Reducing an object to its function is to neglect its creator, who designed the final form and inevitably will have left his or her mark on the piece – even if strictly following the 'rules' of their own stylistic canon. But focusing too much on aesthetics allows viewers to speculate wildly about function, which can result in misinterpretations informed

by supposition rather than fact. They might see monsters, evil spirits or fetishes, where in actual fact there is a portrait of a king or a statue of a god.

Current trends in display

There will always be debate about the best way to display any kind of art. Should the piece stand alone (for example, a clock placed in a glass case) or should it be displayed in its cultural context (the same clock displayed on a sideboard in a replica interior of the period)? In the case of world art the current trend is to aim for the best of both worlds by focusing on both the aesthetics and the ethnological significance of a piece. So the pieces are both scientific evidence and artefacts. These days, when the presentation is primarily aesthetic there are often notes, photos and audio guides explaining the uses of the object, information on the society that produced it, and historical and socio-religious context along with stylistic analysis. Perhaps soon there will be critical studies which take into consideration the over-arching aesthetics of the society that produced it.

Is world art as important as western art?

Whether it's asked openly or implied this question is both absurd and discriminatory – it amounts to asking whether certain civilizations are superior to others. In the past there may have been certain criteria for measuring forms of artistic expression against one another, but nowadays all societies are considered equally valid, so the art which flows from them should be accorded equal respect.

Do the people whose ancestors created these objects approve of how they are displayed in museums all over the world?

Sometimes they do, because the fact that the objects are being displayed means that their culture is increasingly recognized and more widely respected. This method of introducing a heritage or a culture to foreigners or younger generations is also a means of preserving the history of civilizations whose traditions are changing or disappearing. It can also be satisfying to be on an equal footing with other cultures – particularly the erstwhile colonial power – and to see works of art from one's own society cheek by jowl with internationally famous masterpieces such as the *Mona Lisa* in the Louvre. The opening in 1998 of the Tjibaou Cultural

Centre near Noumea in New Caledonia, for example, 'is a symbol of the gratitude and the existence of the people of the Kanak country' and responds to the Kanak 'reclaiming their identity'. As Davi Kopenawa, a shaman and spokesman for the Brazilian Yanomani Indians, put it: 'When people far away know of us and talk of us those close to us will hesitate to destroy us.' Sometimes they don't approve of how pieces are displayed, because ritual objects have no business being placed under a spotlight – they are sacred and according to traditional beliefs they should only be displayed on specific occasions or else remain hidden from the eyes of the uninitiated. Some peoples (Native Americans, New Zealand Maoris and others) object to their ancestors' remains being displayed in museums. Some, like the Native Americans from the north-west of Canada's British Columbia, have campaigned for the return of objects from their culture to museums managed by indigenous peoples. Dispossessed at the end of the nineteenth century by white settlers who believed their customs (such as the *potlatch* ceremony for the exchange of goods) to be immoral, they have now called for the return of their possessions to places like the U'mista Cultural Centre in Alert Bay, opened in 1980. In the United States, the conditions for restitution of confiscated goods have been regulated by the Native American Graves and Repatriation Act since 1990.

Why are these objects scattered around the world, instead of being kept in their countries of origin?

Even though there are now museums on every continent, the concept of the museum itself remains a peculiarly western one, and it does not necessarily have the support of some peoples. Little by little, compromises are made. For example, the Cultural Centre at Vanuatu in Oceania sees itself as a place for interactive exchange between the peoples of different islands, to form a common cultural identity. In this way it is possible to make an audiovisual record of rituals and a cultural life which is still very much alive. But not all objects are designed to be kept, for example the sculptures of New Ireland (fig. 26) which were not made to be displayed but were meant to be destroyed once their function was fulfilled. On the other hand, during the course of history some populations have changed religion, meaning that certain of their religious or ceremonial objects fell into disuse. And of course, there is finally the universal attraction of novelty and

usefulness. People have given away items from their heritage in return for goods hitherto unavailable to them – weapons, tools, fabrics or alcohol. The heritage objects have then naturally travelled further afield.

Were these objects made to be in museums?

Museums undertake restoration and conservation work and are nowadays the means to preserve all kinds of art, from Egyptian antiquities to Italian paintings or Oceanian sculptures. They also have an educative role, taking people on imaginary journeys through time to civilizations of the past, and through space to far-off places where these civilizations are alive today. They offer the opportunity to open oneself to 'otherness', to understand unique cultures, to take on new perspectives and to enjoy global art.

How do museums add to their collections?

Museums used to base their collections on private collections made by ethnographers·or amateurs, or on plundered items, but doing so now is rare. Many now believe that an understanding of other cultures comes not through art alone. In the field, for example, ethnographers will still accept objects offered as tokens of friendship and will buy a few objects on behalf of institutions but they will often refuse a more systematic approach to collecting so as not to compromise relations with the people being studied. Nowadays, the majority of collections are constituted through gifts, legacies and purchases from private collectors at auction. Certain museums also collect contemporary items which demonstrate the dynamism of living traditions.

ART OR CRAFT?

Is it art or craft?

Because objects of world art often have a distinct purpose (for example, in a ritual or social setting) some people think of them more as handicrafts than art. But this is a fairly simplistic view and the differentiation between the two areas is a peculiarly western preoccupation which tends to separate beauty from technique, originality and innovation from reproduction and creativity from beauty.

So how can you tell art from craft?

In the West the cachet associated with being an artist has steadily increased since the Renaissance. At that time artists began to want to be recognized as creators of beauty rather than simply as workmen. They sought recognition that painting could touch people in just the same ways as poetry or music and that their art was therefore more than simply a manual undertaking or a question of technical expertise.

The definition of art continued to evolve between the fifteenth and eighteenth centuries until it was seen as something intellectual, the expression of the artist's thoughts. With this, artists were no longer technicians, decorators or hired craftsmen – they had become innovators. Nevertheless, until the nineteenth century, art was still used for specific purposes – glorifying kings, encouraging prayer, commemorating historic events, decoration, education and so on. Then artists like Claude Monet and Gustave Courbet, free from having to follow a patron's orders, refused to bend to the tastes of the period and instead followed their own personal aesthetics. The West has tended to judge – and indeed still does – non-European art in light of this inexact distinction between 'noble' art (the major art of expression) and utilitarian handicraft, which is seen as minor or of secondary importance. It's a distinction between those works considered unique and crafted items considered reproducible.

So it's not relevant to call non-western creations 'handicraft'?

Only if you reason and conclude that their symbolic meaning (masks, ceremonial costumes) or usefulness (stools, musical instruments, jewellery) far outweighs their aesthetic merit; that their only value lies in their ability to produce an effect (terror in the case of an Oceanian shield for example). Seen this way, their *raison d'être* is to express knowledge of the world and to connect the individual with

society so that society itself can function well and thus preserve harmony (which can be fragile in a world threatened by death, illness and war) or legitimise power or represent an institution.

But researchers have identified any number of societies which have their own sense of aesthetics, thus rendering any distinction between art and craft obsolete. Though the concept of art may not exist *per se* among the Amerindians for example, a sense of aesthetics is fundamental for them in almost every act of daily life as well as in every act of creation. We can see an example of this in the Baniwa fish traps of the Amazon whose beauty and aesthetic sophistication goes well beyond what is required to catch as many fish as possible. Though many of the works of art which we classify today as 'world art' were never conceived to be displayed and admired as such, the care and the sense of beauty with which the creator's imagination has imbued each one means that they are far more than simple versions of the same thing. The desire to combine beauty with function seems to be universal.

What one person considers minor, another might consider major!

Exactly. Different societies consider different pieces to be significant. In fact it wasn't until the seventeenth century that there emerged a distinction between the so-called major arts (painting, sculpture and architecture) and minor, secondary or decorative arts (such as goldsmithing, tapestry and cabinet making). These distinctions resulted from a very specific context and whilst they apply in one culture they cannot necessarily be used in another; so for example the distinction between Art with a capital A (an art created for the elite) and popular art (seen as less significant and created for the people) could only hold in the West. The artistic creations of minority Chinese populations (fig. 19) like weaving and jewellery making would be considered to be simple elements of daily life by this definition, relegating them to the status of minor arts, whereas for those minority populations themselves the items were hugely important cultural and identity markers. Nowadays in world art the frontier between an object of art and an ethnological object is this: the ethnological object is not necessarily beautiful or exceptional – it serves a documentary purpose by illustrating the daily life, the techniques and the cultural specifics of a society. On the other hand, functional objects are considered to be works of art as soon

as they demonstrate a creative value, or a desire to express beauty even if its creator remains unknown. As Marcel Mauss put it in his now famous comment, 'Jam jars tell us more about our society than the most sumptuous jewel or the rarest stamp.'

Did creators from other continents have special status as they did in the West?

As we have seen, the distinction between art/artist and craft/craftsman is somewhat false. People capable of creating objects which their societies see as important for one reason or another won't necessarily be celebrated for their originality or inventiveness, but rather for their ability to respect tradition and conform to the canon of usefulness. They will be lauded for their ability to let the spirits or the gods guide their hand, their skill at giving meaning to the everyday and giving shape to the ideas of their group, not because they seek fame but because they seek closeness to their own people. There is, however, often a discernable distinction between creators of everyday objects and creators of ritual, sacred or political objects; between creators from the court and those of the common people. In some societies only certain people are authorized to make certain objects – and since it's common to praise the talent of one creator in comparison with another it matters little whether they are described as artists or artisans. In Polynesia, artists have always been considered as members of society's elite, on a level with doctors and architects, and they form a privileged and respected class of their own. Among the Mayas of Mesoamerica craftspeople were also specialists working for the social elite.

So how does this way of being an artist manifest itself?

Well, for instance, for the Kilenge people of New Britain in Oceania there are two distinct categories of sculptor – both of which make a living from this very prestigious profession. The difference between them is along similar lines to the distinction between craftsmen and artists. The *namos,* which translates as 'those who produce well made, pleasing objects' might potentially widen their field of expertise to include sculpture, painting, the design and construction of houses or dugout canoes, or even the creation of tattoos and so eventually become *namos tame* – master artists or 'the grandfather, the big man, creator of pleasing objects'.

In fact there are very few who make the transition; those who do are mostly the sons of masters who become masters in their turn.

Do these artists sign their work?

Most of the civilizations we are dealing with here have oral traditions, so any attribution of work happens orally rather than by adding a mark to the work. Few of those who originally brought pieces back to the West thought to ask the names of their creators. The assumption was often made that since there was no signature the artists in question wished to remain anonymous, that they had no interest in being recognized or remembered in posterity and therefore that they had no particular vocation to being an artist.

Since interest in and respect for world art has increased considerably over the last few decades, there is now significant curiosity as to the identity of these artists. But it is very difficult to satisfy; even though some orally-based cultures have retained the patronymics of great artists, not all societies attach the same importance as we do to individual's names. In certain societies the individual is always secondary to the group and one's role always trumps one's name. So in some cases the very fact that the artist's name has been retained at all is highly significant and we can be sure that certain artists (such as Fang, see fig. 14) were extremely renowned – to the point where they were more widely employed than others. But in some cases anonymity is required for religious reasons. Relatively little research has been done on the subject of artistic attribution in world art, so many of our questions remain unanswered.

Attributing pieces to specific individuals

Since we have stopped seeing artists as anonymous workmen, specialists have been able to use the same techniques they have used with western art since the middle ages; gathering together stylistically similar works into coherent groups in order to try to identify a particular school or even an individual artist. In 1937 this approach made possible the first methodological discovery of an African artist originally known as 'the Master of Buli', after the village in the Democratic Republic of Congo where one of his sculptures was located. His memory was so well preserved in the region that, more recently, it has been possible to find the village where he practiced (Kateba), and then his patronymic, Ngongo Ya Chintu

(which is itself a kind of title, 'Grand Master Sculptor'). A similar method has allowed us to indentify 'the long-fingered Master' of the Haïda people on the north-west coast of North America or certain contemporary artists such as David Malangi in Australia (fig. 24).

Did these artists create works exactly as they wished?

As with most western artists up until the end of the nineteenth century, these artists tended to work to order, which suggests following traditional designs and limiting the development of a personal aesthetic. Earlier in their careers, even artists like Picasso and Matisse could not give their imaginations completely free reign as they still had to produce art which met the specific needs of their public. That's why a quick glance is often enough for experts to be able to tell where a piece comes from – it is easy for an expert to tell the difference between a sculpture from New Ireland and one from New Caledonia, for example, or between a Javanese puppet and a Balinese one. The more one sees of objects from a particular region, the better attuned the eye becomes and the better one becomes at identifying first styles, then artistic personalities, and eventually stylistic influences at play within certain cultural zones. One realizes then that the distinctions between different styles known as 'ethnic' are not as clear as has long been believed. Newcomers might think that all Punu white masks (fig. 16) look alike (the same white faces, same small almond eyes, same hair) but each one is unique in terms of both artistic expression and balance. Some are more accomplished than others because respect for artistic tradition has never stopped talent from shining through. What is more, as with art from any part of the world, non-western art is full of reinterpretations and innovations.

So outside of Europe, how did you get to be an artist?

There are as many different routes to becoming an artist as there are societies. It is thought that schools or artists' studios probably existed – particularly in societies which were organized into kingdoms or empires and in which artists gathered into guilds (like in the kingdoms of Benin or Nigeria). In some societies anyone could become an artist, but in others you had to belong to a certain group to be allowed to receive the status and the knowledge handed down on a hereditary basis. Your apprenticeship would take place either alone or with a

master, often with the involvement of the spirits, and the training (overseen by the ancestors) would sometimes be in secret. In West Africa you might choose to be an artist out of social aspiration, so you could follow a dream or in response to the spiritual powers or to follow in your father's footsteps. The apprentice's age and the length of the apprenticeship varied enormously. Among the Lobi people in Burkina Faso it included taking plants known as 'medicaments' to protect against madness inflicted by bad bush-spirits.

Can anyone see sacred works of art?

The ritual function of certain objects does make them particularly inaccessible to the general population – they are usually hidden away in special places, such as the Chiefs' treasury in Cameroon (fig. 13). A certain mask might only be brought out on the rare occasion of a particular ceremony, or a sculpture might only be used by a certain section of society under very precise circumstances and must never be seen by others or it would lose its powers. So many of the objects which were brought to the West had never previously been seen out of the context of their particular function. African statues used in initiation rites for instance are often forbidden to be seen by the uninitiated (women, children and outsiders). It's the same for certain pre-Columbian deity sculptures which were placed at the top of their pyramids in temples reserved only for nobles and priests. However, not all non-European pieces are sacred and so they can be seen by anyone, including architecture, jewellery (see the Dayak earrings, fig. 21) and costumes (see the Gusoku armour, fig. 20).

Isn't it wrong to display ritual objects that should only be seen in their original context?

As soon as any object that has not been made with the sole aim of being admired is exhibited in a museum, it loses its primary function. Once it is hung in a gallery the religious picture which served to help believers in their prayers loses this purpose and becomes something to be admired, an historic object. Whether it was made in the East or the West, in Africa or in Oceania, 'art is what's left when an object no longer has a use', as Claude Roy put it.

How do museums chose their key pieces?

It's not easy to know which items will be considered more beautiful than others and will remain in the archives but, in any case, some museums choose to reflect art's diversity rather than focusing on what makes pieces exceptional. You might think works would be selected based on their uniqueness or on the talent of the artist, but if it's important to the collection to allow comparison with similar but less accomplished pieces (with less finesse or expression to a face, for instance) then other factors might include rarity, age or provenance. Its pedigree might also be important. Did it used to belong to a prestigious collector? Has it appeared in numerous publications? Has it made history at auction? Sometimes when the public as well as the museum's buyers and conservation teams come to consider an item as a masterpiece, its history since its arrival in the West is almost as important as the artist's talent or the significance of their ethnic group.

But we are judging the art of others by our own criteria

Unfortunately it's difficult to do otherwise. Whether we want to or not, we all see art in a way that is conditioned by our upbringing and our own cultural aesthetics. In the West, in general, we love to be impressed (hence the popularity of monuments like the pyramids) and we celebrate refinement (we attribute great importance to items made of precious materials like gold or ivory). We also appreciate objects which look 'finished' (we often favour polished objects without any tool marks), we can be dazzled by history (we are fascinated by empires and monarchy), in awe of the ancient world (there is a preference for historical objects), and impressed by naturalist or lifelike reproduction.

Seeing other ethnic groups through the prism of one's own culture and assuming that culture to be a legitimate yardstick is known as 'ethnocentrism'. There are two main dangers to this: firstly, if we refuse to believe that something which doesn't follow our rules of aesthetics might actually be beautiful we miss out on much of the richness and diversity to be found in difference. Secondly, there is a danger of seeking too much 'otherness', of always focusing on dissimilarity, on the strange and the exotic, thereby distancing ourselves from anything which risks bringing otherness too close to home. This is why nail sculptures (fig. 8) have been so well known for so long – they offer a glimpse of another reality that is at once fascinating and repugnant to many of us. Value is not conferred on art by exoticism alone.

Masterpieces should be the same for everybody!

Many of the works westerners describe as masterpieces are also the ones most admired by their originators' people, but this isn't necessarily always the case because different perspectives will always be at play. A religious piece for example might be significant because of its ability to communicate with the spirits, with its power only being reinforced by its beauty – in this case beauty takes second place. Conversely, a piece taken out of its original context and displayed in a museum might be prized for its beauty and evocativeness over its ethnological significance. It's rather early to judge whether the idea of the masterpiece is relevant on other continents – linguistic and semantic studies reveal the existence of specific terms to describe particular artistic excellence or the taste for 'successful' pieces generally (like Susan Vogel's work with the Baoulé in Ivory Coast) but these studies are far from numerous.

Do people still appreciate the things that were popular at the beginning of the twentieth century?

Yes and no. The objects which were already admired – and expensive – in the twentieth century remain so today. For example, many of the items selected for a Paris exhibition in 1965 at the Musee de l'Homme were again chosen for display in the Louvre world art exhibits in 2000. But it's not always the same items that have been popular. With Asian art, for instance, Europeans originally preferred royal art, before discovering tribal art. In the early twentieth century there was a definite preference for objects formally similar to western art – those displaying realistic proportions in the human form, refined lines, or made from materials like ivory, stone and hardwood that were durable or pleasant to touch. But for the last thirty years there have been more collectors and they have taken an interest in much more diverse works, some of which are considered to be less classical. In the past, the fashion was for artworks to be cleaned; curators would have sculptures (particularly African ones) polished to remove the patina, which these days is highly prized.

Are the pieces displayed in museums unique?

What we see displayed in museums tend to be archetypes rather than prototypes – that is to say they aren't copies (they are original works in their own right) but

neither are they full originals (in as far as other works resemble them). Not every society prizes uniqueness. For example, the carving of an elder from Nias Island in Indonesia (fig. 22) is a seated man wearing jewellery (headdress, necklace and earrings) but it is by no means the only carving of such a figure from the island. They weren't made as a series so they have original characteristics such as the proportions of the body, the shape of the headdress and the realism of the subject's features, as well as displaying the personal style of the artist.

What about sculptures bought on holiday? Do they count as works of art?

Most of the masks, stools and carvings sold in markets are pale imitations of traditional objects – they are produced to meet tourist demand for exotic souvenirs and are designed specifically to appeal to the customers' taste. Some may display talent or originality but many will have been made far from their supposed homes – some quasi-Oceanian objects are actually manufactured in Africa! It's quite common to find objects which exploit traditional motifs but have no ceremonial or symbolic use and are produced solely for profit. Such decorative objects are an inexpensive way to become familiar with different styles of artistic expression and of opening the door to further discoveries in museums or galleries and they do have a certain sociological value as they help us to understand the links between ancient and contemporary art. Plus of course this kind of art is sometimes also of a very high quality. Some pieces aimed at the tourist market, like some of the Inuit art in Canada, do not slavishly follow the fashion of tourist demand but instead represent an admirable renaissance of traditional art and identity.

So what makes a piece authentic?

An authentic work of art is one not only made by the people to whom it is attributed (and subject to no external influences) but one that is also used by those people. But there are problems with this definition: for example the rectangular plaques from Benin (fig. 12) may have been inspired by the shape of books imported by the Portuguese from the end of the fifteenth century and Yoruba headdresses probably imitated the headgear of the Catholic church's senior clergy. Forms and styles from one culture blend with and influence those

from another, and it has always been the case that any artist who works for people from a different culture contributes to the circulation of ideas, styles and forms. So in fact, there will never be a clear distinction between what is authentic (without external influences) and what is considered 'hybrid' (art that incorporates external influences). There is much debate about how to classify atypical objects. If they display several influences either they don't fit neatly into any category or they fit into several at once! Hybrids have for too long been looked down upon, but resulting as they do from trade, exchange and innovation they are an important source of richness. The myth of purity and authenticity is just that – a myth.

How can I tell if it's a fake?

It's a fake if it was produced and passed off for sale as an original historical object or one that had actually been used. The lucrative art market has long been fed by a flow of forgeries; so-called pre-Columbian objects were appearing as early as the first half of the nineteenth century. Though the quality of the forgeries continues to improve – to the point where they catch out some of the most prestigious experts – so too do scientific dating techniques such as carbon dating, dendrochronology and thermo luminescence.

Is world art expensive?

In recent years world art prices have risen sharply due to the sale of some prestigious collections which have literally blown away the estimates. In 2005 several African items including a Luba-Shankadi headrest and a Fang ceremonial fan passed the million dollar mark and a Lega mask sold for just over US$2.9 million (£1.6 million). Today, in galleries, we are starting to see small objects sell for about US$700 (£450). Around US$3,000 (£1,900) will buy something modestly-sized but beautiful, and for something really exceptional the price tag could be upwards of US$15,000 (£9,400). Works where the artist has been identified or which have been part of collections named after their illustrious owners – the Vlamincks, Derains or Picassos – cost even more.

SOME KEYS TO READING

Before you look

It can be difficult to appreciate something that is foreign to us
You would be forgiven for thinking that it is hard enough for adults to appreciate unfamiliar objects from very distant cultures let alone for them to help children do so. That may be because it is all too easy to focus on what something is used for rather than how it looks. But not knowing about an object's function certainly doesn't stop us from looking at it and even from registering an emotional response to it. And that's exactly how children deal with the world; simply looking at things without first having to understand them appeals to them and captures their imagination. In any case, there are so many things that even the experts don't know about non-European art that it's sometimes best to avoid the historical or ethnological route which may well bore children. It is often easier to admit that you don't know about a faraway civilization rather than struggle to rattle off a list of kings or presidents, and anyway, children don't really care! They usually prefer to keep things simple and they love to have a good stare and talk about what they feel. The trick is to use the same straightforward approach and then if you want to guide them a little it's quite OK to pretend you don't understand either.

How to make head or tail of all the different countries and tribes
Many of the names can be hard to pronounce or remember – even for serious fans of world art. Depending on how old the children are you can help them situate unfamiliar civilizations geographically in terms of continents, countries or regions. That said, like Picasso or Matisse who cared little for the origin of this kind of object, it's quite possible to appreciate world art without having to place the object in its precise geographical context. An atlas will help you pinpoint the countries the works of art come from and the specialist maps sometimes found in museums and books can be even more helpful. Some better known civilizations like the Aztecs and the Egyptians are generally associated with very specific places but others may not be, for example those with few members, those limited to a small area or those whose names have changed like the Kwakwaka'wakw, previously known as the Kwakiutl (see fig. 2).

Peoples, tribes or ethnic groups?

The expressions 'ethnic group' and 'tribe' are used to refer to a group of people sharing a language, a culture, a defined area and political, religious and social customs or institutions. If the term 'tribe'– which subsequently became controversial – seemed in the past to be applied particularly to non-western groups that's because it was originally used to describe groups considered to be less evolved, whereas the term 'peoples' was reserved for populations thought to be more civilized. These days we are more careful about when and how we use the term 'ethnic group' and where possible try to use more specific terms such as 'population', 'culture', 'civilization', 'community', 'society' or 'nation'. We tend to use expressions like 'members of early societies or civilizations' and the term 'indigenous peoples' is preferred to 'natives'.

What kind of specialists focus on world art?

Anyone studying the history and workings of another society is likely to refer to its works of art. So the academic disciplines involved in such research and in improving our understanding of world art are so numerous and they overlap to such an extent that it is often difficult to distinguish one from another.

The **ethnographer** studies societies different from his or her own, focussing on human groups and their histories – with a particular emphasis on pre-industrial societies with no written tradition. Ethnographers will spend time – often several years – living with their subjects so as to understand their lifestyle, their family structures and their religious, economic, social and political practices. The findings are presented in ethnological reports. Then, on their return, the ethnographers' information gathered in the field is synthesized and analysed in a research monograph providing as much detail as possible on the group in question or on an aspect of their lives such as initiation rituals or kinship. The prefix 'ethno' can also be added to the names of other academic disciplines to denote a dual specialization, for example ethno-botany, ethno-musicology, ethno-psychiatry or ethno-aesthetics (the study of an object in terms of both form and cultural context). Ethnographers focus on what are known as 'traditional societies' and therefore deal with the social aspects of a group from which they remain separate. **Sociologists** focus on what are known as 'modern societies', observing the social aspects of their own communities. By contrast, the **anthropologist**

is not so much interested in people gathered together in societies as in human beings. The meaning of the term anthropology has broadened to represent the comparison and theoretical study of ethnological findings as a means of deepening our understanding of man. Anthropology itself includes a number of sub-specialisms such as biological anthropology, the anthropology of art and social and cultural anthropology (in the English speaking world this latter term has become almost synonymous with ethnography). **Archaeologists** study ancient civilizations using material evidence primarily found during excavations or digs. **Historians** use the information provided by archaeologists and numerous other (written) sources – such as letters or ships' logs – to piece together the sequence of events of the past. Most **art historians** tend to focus on European as opposed to world art, and study the development of form and technique. **Linguists** take a scientific approach to the study of languages and dialects. Their work builds our understanding of the origins of certain ethnic groups; how they have expanded and how they are linked to other groups, clarifying amongst other things the cultural exchanges which may have taken place between groups.

Do these academics have Indiana Jones-style adventures?

If you read some of their works you will see that many of them did indeed have tremendous adventures. They travelled to the far-flung corners of the world, often putting up with difficult transport and accommodation and they had to get used to different climates, to fight off illness and surmount huge difficulties in communication.

They are true heroes, inspired by their passion. Quite apart from their contribution to the great adventure that is science, these academics had amazing adventures of their own.

Bringing world art into a child's world

Making connections with things a child is already familiar with is a great way to get them interested; link art with music or dance they like, with a friend's family background, with holiday plans, with books about different civilizations, or films set in different countries or make a connection with ethnic fashion (non-European clothes, jewellery or decorative items). The *haka* (the generic term for the New Zealand Maori dance) is chanted and danced by the All Blacks before

their rugby matches and never fails to make an impression on children and adults alike. Next time you are at a museum or looking at a relevant book it's worth pointing out that the expressions on Maori carvings (eyes bulging and mouths wide open) is similar to the rugby players' faces during their dance!

Do you have to prepare for a visit to an exhibition?

Yes, if you suspect that the beauty of the works alone won't be enough to captivate the children, you should do a minimum of preparation before you go. Of course you don't need to have an encyclopaedic knowledge of what you are going to see, but you might find it useful to familiarize yourself with the basics. The important thing is to get the key messages across – for example, that the pieces you are seeing come from far away, that they are unique and that though they weren't created just to be on display in the museum they are works of art nonetheless. Without being too pre-emptive you can help to sharpen your children's observational skills by showing them pictures of the works you will be seeing ahead of time. They can then have fun finding and recognizing them.

Value individuals and respect difference

Some of the traditional customs (like stoning or female circumcision) that are unfortunately still in use are genuinely shocking and many sociologists and ethnographers have joined the fight to outlaw them with good reason. However, getting to know how others live allows you to set aside your preconceived ideas and not be afraid of differences. Children do not naturally harbour prejudices so teaching them to value different cultures through an appreciation of different artistic traditions is simple. If from the outset we put the creator of a Nok carving on the same artistic level as, say, Henry Moore, they will be aware of how many diverse kinds of art are out there and how each is worthy of admiration. If every kind of artistic expression is worthy of respect then the same should be true of every kind of lifestyle, custom or society. Refusing to understand other people can become a two-way street. Recalling the encounters between westerners and Indians in the sixteenth century Claude Lévi-Strauss wrote 'While the whites denounced the Indians as beasts, the latter were happy to suspect the white men of being gods'. Art is also a means of understanding a society without relying on images presented in the media (there is much more to Africa than war, famine

and AIDS, for example, and Burma is more than the 'giraffe women' whose necks are permanently stretched by their necklaces and who have been turned into a tourist attraction). Human beings are not objects and it's important not to be voyeuristic (like those early twentieth-century westerners who flocked to the human zoos).

A chance for some to (re)find their roots

Being exposed to items from their culture of origin can be extremely affirming for refugees and exiles as well as for people whose family origins are non-European. They can feel a sense of pride in themselves when they see their heritage displayed in prestigious museums on equal terms with masterpieces like the *Mona Lisa*.

But do be careful when discussing the concept of 'origin' with children. Being 'of colour' does not make a child foreign, and neither does it mean he or she embodies all the diversity of a continent. An adopted child, for instance, may never even have visited the country of their birth.

Younger children are likely to be more comfortable hearing about the country of their forefathers but some adolescents who are trying to find themselves (at an age when fitting in is very important) may not feel comfortable being attributed with such distant origins.

Even among those children who are familiar with the countries of their birth – having spent holidays there for instance – there will be some who are far from familiar with its culture and customs; traditional art, masked dances, the hut where one sleeps on the ground may all seem perfectly strange to them too!

At what age will children be interested?

From around four or five. At that age they still enjoy doing things with their parents and, free from any preconceived ideas, they can plunge into a new world. Be careful not to let visits go on too long and don't spend too much time on the things that interest *you*. Focus instead on the things *they* are drawn to.

Face to face with world art

Where to see world art

It doesn't matter – you might start the encounter with a book, a gallery, a documentary, an advert or a film. Or alternatively you may choose to start at a museum where you know you will see high quality items.

The best way to visit

Before you go, make sure you know a bit about what you are going to see. Some museums produce information for adults and sometimes also for children (with games and quizzes for example). Even an exhibition map can be a great help in getting the kids involved – some children like to get their own bearings rather than being guided. Many museums run tours, workshops, lectures and storytelling sessions as well as dance and music events for younger audiences. Help concentration and maximize the chances of creating happy memories by making the visit playful and interactive.

Which objects to see

Not everything! Best to see the things that inspire you or that the children want to see. They are generally impressed by large things or items that are funny or scary. Don't worry if they don't stop in front of the better known works of art – there will be plenty of time on another visit!

How to look at a piece

Adults tend to home in on works they are already confident of understanding because it's reassuring to focus on what you know. Make the most of being out with children to focus instead on what you feel. Stop in front of a piece and look carefully at it, describe it as a whole without being obliged to explain what it's for or where it comes from. Unencumbered by knowledge you will often be able to see more freely and notice more detail – like the upholstery nails in a *Nimba* sculpture (fig. 8) which adults are more likely to miss than children. Of course knowledge is essential to understand works of art but it won't necessarily help children to appreciate them! You can leave discussions of cultural foundations and the creative process until later.

How to get talking

Don't tell children what you know; ask them questions instead. It's easiest to start with feelings. Ask them their opinion and give them yours; together work out what it is that attracts or repels you. Teenagers tend to find it easy to be critical, especially of things that are different to themselves. Help them to express their personality and their personal aesthetic without judging others; just because you might find the *Mona Lisa* ugly doesn't mean that all Italians are rubbish!

Description – an excellent teachers' aid

Describing a work of art is a great way to identify it but also to focus children's attention. You may be surprised by their unguarded observations. If they say 'it's a horrible monster' that's probably not a criticism but a spontaneous expression of their imagination. Chatting can help you find words to describe what you see and the feelings it evokes. See whether they find it frightening or reassuring by imagining where you would put it at home. Putting that scary carving in front of the house to frighten off intruders would turn it into a benevolent carving and teach them that appearances can be deceptive. Help them to connect with a carving by having fun copying its pose and its expression (like the Mbala headrest, fig. 17, or the Hawaiian head, fig. 29). As they mime the bits that are extra long or short they'll see that the limbs, or in fact the whole carving, aren't meant to be true to life. Ask them about the decoration, the hairstyles, the materials; shells, fabric, raffia, straw or wood (sometimes transformed by its patina to appear metallic – like the Dogon carving in fig. 10). Explain to them why they're not allowed to experience the carvings' texture by feeling them.

What do the notes say?

Exhibition notes – which children who can read might enjoy deciphering – tell you as much as possible about the piece. Generally speaking, after the title which tells you what kind of object it is (mask, weapon, statue), the card will mention the tribe or origin of the artist if these are known (David Malangi for the Australian painting, fig. 24). Depending on how much is known about the work's origin it should be possible to find the precise place on a map (by reading the caption on fig. 25, for example, we know that the carving from Papua New Guinea comes from the village of Chimbut on the Korewori River in a cultural

zone known as Sepik, from the name of another river). Or alternatively, the information might be so vague that it covers a whole country. The dates when the piece was made and/or collected may be included if they are known, then the materials, the dimensions and finally the place where it is held. Sometimes the name of the collector or collections to which it has previously belonged are also included, along with any additional information (how it would be used for example, or how it was found).

Lots of it doesn't look real

From the Renaissance right up until the nineteenth century western tradition (informed by its love of Greco-Roman sculpture) used the depiction of reality (or even improvement on reality) as the yardstick for artistic perfection. It was thought that the more a work could move beyond simple imitation and show how nature could be improved upon, the more beautiful it was. This focus on naturalism, combined with a desire to perfect nature (whilst still respecting the proportions of the human body) was a very western preoccupation. From the twentieth and twenty-first centuries naturalism may not have been the objective of most western art but it had never been the objective of most non-western art. For the Yoruba in Nigeria, for instance, if a carved face looked too much like its subject it could be an exterior wrapping but if it was stylized it would be a manifestation of the interior being. Too close a resemblance risked serious consequences so carvings had to be neither too realistic nor too abstract. But that didn't stop the decoration in terms of hairstyles, jewellery and clothes from being realistic.

Lots of it is dirty and broken!

Lots of children and also some adults don't like to see broken objects on display (missing an arm or a head, for example) or objects that seem dirty (but might just have traces of old pigment or patina). They would often prefer that the missing pieces be stuck back on or the objects be cleaned. But exhibits aren't left dirty or incomplete out of a lack of consideration for the public, on the contrary it is out of respect for the art itself, which ought not to be reinterpreted too lightly. Splits, cracks and holes can result if the wood wasn't quite dry enough when it was carved, or if it's been subject to changes in climate during transportation

from a hot country to a cold one. In fact temperature and atmospheric moisture control is managed in museums by machines that create little graphs. Children may enjoy looking at carvings – particularly ones that were designed to be driven into the ground (like the Senoufo statue, fig. 11) and have been gnawed by wood-eating termites. Older children may be interested to learn that studying these differences in pigment and patina can provide clues about how the piece was kept and therefore about its original use. To halt damage caused by living creatures works are often stored in rooms deprived of oxygen.

Do people know everything about the pieces on display in museums?

Far from it – sometimes we don't even know what continent they are from! Afro-Portuguese ivories, for example, were for a long time attributed to the Indians or the Turks and were only finally correctly attributed through the study of the materials, the iconography and the carving techniques in comparison with similar pieces. A lack of archaeological research means that some pieces (particularly those from illegal digs) provide little information about how they were used and by whom. Even if we can be sure about the origin of certain pieces, we may not know how they might have been used (like the two-headed serpent Aztec pectoral from Mesoamerica, fig. 5). What is more, some communities don't divulge any information about some of their art (like the communities in Vanuatu who are known for the mystery surrounding how their societies function). Even if anthropologists know the secrets they may chose not to reveal them out of respect for the community.

Is the dating accurate?

Not always; for example it's impossible to date the stone sculptures on Easter Island (fig. 30) because there simply aren't any sources. Taking an interest in dating works of world art is only a recent phenomenon. Previously they were thought of as either ageless (because it was thought that their tribes were not concerned with innovation and happy to endlessly repeat the same thing) or recent (because it was thought that wood did not last in the African climate). Nowadays chemical dating and written evidence sometimes allows us to prove how ancient certain pieces are – like the wooden carvings from Mali which have

been dated to at least the thirteenth century – but dating, particularly where it is based on stylistic similarities, remains an approximate science.

Are some of these objects magic?

The pejorative terms 'fetishes' or *grigris* were once used in the West to refer to objects with supernatural powers from Africa, America or Oceania. In a period when these places were being evangelized many such masks and statues were consigned to bonfires as they were seen as evidence of 'black magic' (to use the Christian term) and blasphemy. As a result of the mystery and fear these objects engendered many of their associated rituals (such as the Voodoo rites of Benin, the Antilles and New Orleans) were denounced as the work of the devil. Magic was often thought to be in opposition to religion; it was seen as having only evil objectives whereas religion had only good. The cries of devilry only increased following depictions in Hollywood movies highlighting the rituals' more sensational and frightening elements. Many world art objects are linked to religious cults (or, to use less disparaging language, to magico-religious practices). Others are used in daily life – they might be the manifestation of a chief's power or they might provide information about a person's status, but they are not sacred.

What is animism?

Animism is the term used to refer to any kind of 'traditional' belief as opposed to the monotheistic religions (Judaism, Christianity or Islam) or to eastern philosophies such as Hinduism or Buddhism. It was once thought that animism was simply embryonic monotheism (when monotheism was believed to be superior) but it really is a religion in its own right. Practiced particularly in agrarian societies, animism is described by some as the world's third religion (after Christianity and Islam). It sees the world as peopled by one or many spirits and attributes human characteristics (a soul) to things like rocks, clouds and animals. Often wrongly associated with magic, superstition, sorcery and idolatry the term 'animist' was frequently applied to peoples who were so poorly thought of that they were believed to be incapable of religious conviction. So the term remains somewhat controversial; it's not used to refer to the prestigious Egyptian civilization for example, which is usually described as polytheistic.

What is syncretism?

Syncretism is the combination of several faiths, for example the fusion of an imported religion like Islam or Christianity with traditional beliefs. In Brazil the Afro-Brazilian religions (like Candomblé, Umbanda and Macumba) are the result of cross-fertilization between animist, African-Creole and Christian sources.

Preconceived ideas

'In South America the Indians only work with feathers'

This is false. Even though feathers are considered noble and remain a preferred material for many tribes (censuses tell us that there are some two hundred and twenty groups in Brazil alone), they also work with basketry and other natural materials. Digs in the north east of Brazil have unearthed funerary urns of up to a metre tall, displaying both technical skill and artistic beauty, so we can be certain that other materials such as clay also had their place.

'In North America the Indians were warrior nomads, scalping their enemies and travelling on horseback'

This is partly true – if a little reductive – and it's also partly false because they were initially sedentary agrarians only becoming nomadic following the domestication of the horse (introduced to America by the Spanish and returned to the wild). That allowed the Indians to better organize their buffalo hunting and to defend themselves against successive waves of invaders. The image of the redskin (they painted their skin with red pigment) was essentially created by cinema and cartoons and has become so widespread that now Brazilian children play Indians and dress up as North American redskins often without even knowing about the Indians in their own country!

'African art is all about masks'

This is not true. Masks may have been more heavily collected because masked performances (secret or public) would have made a strong impression on travellers and photographers; a stronger impression perhaps than fabric or jewellery or than carvings which, whilst numerous, were less visible being kept and used indoors.

'In Africa the only material they used was wood'

False. Though wood is extremely widely used, stone is also very popular, as is metal and clay (particularly in ancient civilizations).

'In East Africa there are neither masks nor sculptures'

This is false, although decorative art is perhaps less abundant and certainly less well known there than in Central or West Africa. In East Africa the artistic expression is found rather more in everyday objects which tend to be smaller and more abstract in form (headrests, weapons, jewellery). It is also found on the body itself (body painting and hairstyles) and in music and in the oral tradition. In fact, certain peoples in Ethiopia, Somalia and Kenya have created extraordinary objects including shields and seats.

'There is no tribal art in Asia'

False. Europeans initially collected royal Asian art but took much less interest in the masks and clothing of the common people, the shamanic objects and sculptures, as these did not correspond with western aesthetics. As a result they are simply less well represented in museums.

'In Oceania people are cannibals'

Cannibalism, which did exist in Oceania, has always been a source of fascination. But when the image of the 'savage' was created the idea became a caricature; people imagined that the Oceanians happily ate one another and would boil alive in a big pot any white men they happened across. It took some time before cannibalism itself was studied but when it was people understood that it was a ritual custom never designed to satisfy hunger and in some cases was pure fiction. There are various plausible interpretations for such a symbolic act which effectively demonstrates respect for the cycle of life; destruction of an enemy (in body and spirit), the appropriation of an enemy's strength, transfer and perpetuation of the soul and the absorption and reintegration of deceased members of one's own group. It's not the enthnographer's role to approve or condemn such practices but to understand how they work and what they mean. According to Claude Lévi-Strauss 'The only question the ethnographer should ask is "What is cannibalism?" (in as far as it is something) and not in itself, or for us, but for those alone who practice it.'

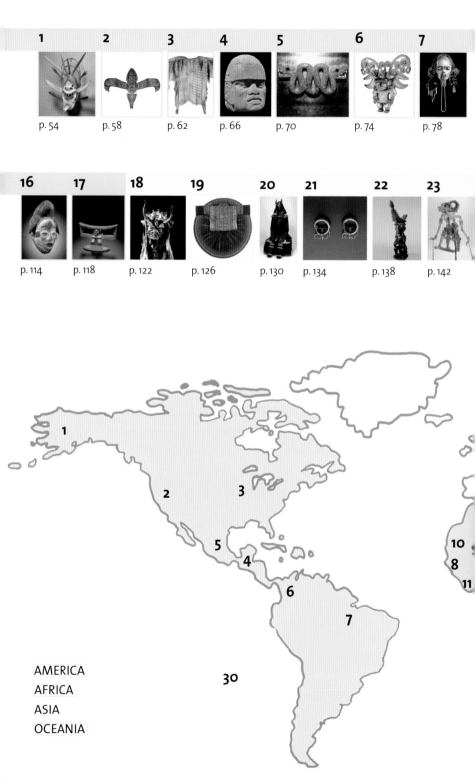

AMERICA
AFRICA
ASIA
OCEANIA

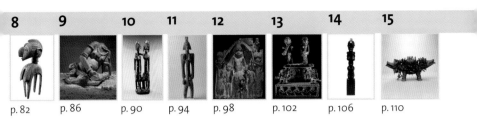
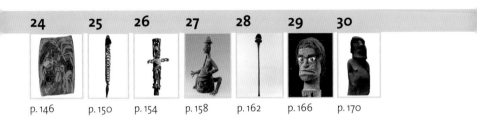
FEATURED WORKS

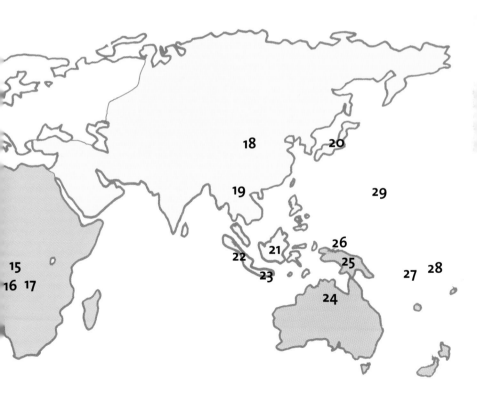

HOW TO USE THESE PAGES

Do the thirty works in this book represent all of non-European art?

They do in as much as they come from the four other inhabited continents (Africa, America, Asia and Oceania). But of course a small book like this can never hope to be exhaustive; thirty objects can never represent three quarters of the world's population (the eight works selected for America, for example, cannot possibly cover the true diversity of the continent). Lack of space has meant that, despite their undeniable significance and having produced extraordinary art, several cultures have had to be left out entirely – these include the Peruvian Incas, the city state of Ifé in Nigeria, New Zealand's Maori and all the peoples of Asia's Golden Triangle (Thailand, Burma and Laos). There is no shortage of wonderful private collections but these aren't always accessible to the public, so all the works in this book are to be found in the major museums of the world and they all belong to often-displayed stylistic families so that everyone can have the chance to see them for themselves.

How are the featured works presented?

The commentary provided for each work is based on the questions and remarks that children are likely to make, or the observations which might occur to anyone looking at them for the first time. The text is designed to arouse curiosity and is presented in age-appropriate sections. The colours beside each paragraph correspond to very small children of nursery school age (red), older children of primary school age (yellow) and youngsters of secondary school age (blue). Little ones will enjoy finding out what the piece is and letting it fire their imagination whereas slightly older children often like to interpret and think about the pieces and perhaps to discuss them. Older children may be interested in relating the work to what they already know about history and ethnography. But there are no hard and fast rules about who will like what and their questions will depend on their personalities. Anyway, you will be able to read the questions separately and adapt your chats according to the children's reactions. And of course you can invent completely new questions too. The name of the game is to be completely open to the art and to realize that even when you think you don't know anything about it you always know more than you thought. And one thing is for sure, you will always know enough to help children enjoy it.

What order are the works presented in?

The book is organized along geographic rather than chronological lines. Ancient pieces follow more modern ones and vice versa. The pictures are arranged by continent so that you and your children can easily follow a trail around the world. Starting in North America the trail moves to South America then on to Africa (mainly West and Central Africa) and into Central Asia and South East Asia before reaching Oceania and Easter Island (the closest inhabited land to the American continent). And that completes the circuit.

How were the pieces in this book chosen?

We have aimed to give an overview of the diversity and the inventiveness of artistic tradition across the four continents, so the pieces chosen are all aesthetically and historically significant and/or representative. Most of them come from the better known peoples of each continent (like the Aztecs or the Dogon) and they are presented here because of their iconographical, historical, technical or ethnological importance – providing the opportunity to give lots of additional information. Sculpture is important on all four continents so there is more of it here than other art-forms, it also appeals particularly to children who enjoy judging size ('it would fit in my hand', 'it's bigger or heavier than me'). They also like to touch things. Of course, that's not allowed in museums so have them use their imaginations instead and make believe they are feeling the softness, the smoothness, or the roughness of the pieces they see. Have them mime the poses so they can understand the deformities or see what a difficult posture it must have been for the subject to hold. As well as sculpture this book includes other works like paintings, jewellery, weapons and textiles. All of them attest to the diverse nature of art around the world and demonstrate that every nation has its own aesthetic.

Red: 5–7 year olds (or beginner)
First and foremost: identify what it is you see in the works. This is not always straightforward. Identify the various elements of an object that you might otherwise tend to look at only in its entirety.

Yellow: 8–10 year olds (or intermediate)
Slightly more searching questions lead to a deeper understanding of the works. These require some thought.

Blue: 11–13 year olds (or advanced)
The works are seen in relation to the outside world. The motivations of the artist are described as well as the historical importance of the work.

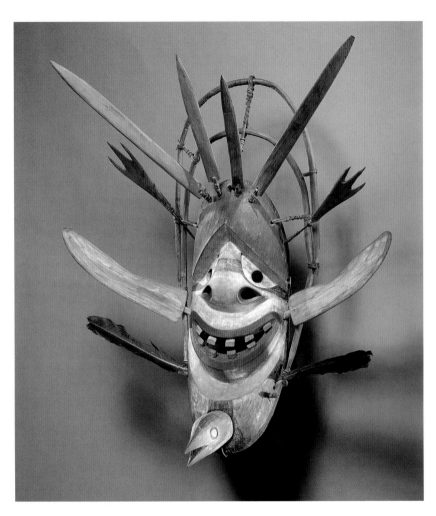

1 Yup'ik mask

Anvi, Yukon, Yupiit Alaska
Late nineteenth century – early twentieth century
Painted wood and feathers with bentwood hoops. Height 61 cm
The Michael C. Rockerfeller Memorial Collection (1979)
Metropolitan Museum of Art, New York, USA

A smiley-face mask!

Yes, smiley masks are somewhat rare – apart from among the Alaskan Yupiit. As a tribe they are famous for their very expressive masks, which either have grimacing mouths or smiles from ear to ear, like this one.

What are the things around the face?

There are two harpoon blades at the temples, two feathers under the mouth and a model of a bird's head protruding from the chin. The wooden hoops form a kind of double halo around the face and would probably originally have been covered with fur or feathers. Some researchers believe these halos represented layers of other worlds according to the Yupiit world view and they served to anchor the wearer of the mask to his own universe.

The colours are all faded!

Unlike the masks made by north-west Canadian Indians, the Yupiit masks were not painted with imported chemical paints. Their colours come from natural sources such as plants and minerals like ochre, ash, copper oxide and white clay. The translucent paint allows the grain of the wood and the sculptor's tool marks to be seen.

◊◊◊

Are the Yupiit Eskimos?

Yes, the Yupiit are among the inhabitants of the arctic regions which extend from eastern Siberia to Greenland via Alaska and the north of Canada. Westerners call them 'Eskimos' (which has been translated as both 'eaters of raw meat' and 'speakers of a foreign tongue'). The people concerned in Alaska generally prefer the term 'Inuit' (which means 'men'). The name Yupiit (meaning 'true men') is given to people living in south-western Alaska on the coast of the Bering Sea and sharing the Yup'ik language and culture.

Do the Yupiit live in igloos?

No. The igloo (snow house) is the traditional home of Canadian Eskimos in the central arctic region but it is rare in Alaska. There aren't any trees in that part of the world – it's tundra, where the ground is covered in low vegetation and frozen for a large part of the year – so the Yupiit build their houses from driftwood carried there by the river or the sea from the abundant forests south of the Bering Strait. They cover their large, rectangular, semi-underground houses with earth and moss to provide insulation. The same driftwood was also used to make masks. The cold climate means that the Yupiit could not grow their own food, so they lived by fishing and hunting. Unlike many Eskimo communities their region offered plentiful wildlife, so they were able to live in fixed settlements.

◊◊◊

Is it a religious mask?

Although most Yup'ik masks were used for religious purposes we can't be certain about how this particular mask was used. As missionaries imposed Christianity on the Yup'ik their belief system effectively came to an end around 1910. So it's very difficult for ethnographers to understand the role of these masks which were already obsolete. It's thought that the masks acted as intercessors – for example praying that the hunting season would be successful – and so they were designed to honour certain animals, flatter the spirits or recount ancient stories. Half man and half animal, they reflect the duality found in Yup'ik spirituality: according to the Yup'ik all living creatures have the ability to transform themselves into animals and then back into human form. Under the blanket of their outer bodies animals and humans are one.

What spirit does this mask represent?

It's difficult to answer that simply. It's likely that this mask represents a bird like the one that appears – albeit rather small – on the chin. The human face might symbolize its *yua,* its soul or spirit. Yup'iks believed that every creature (both men and animals) but also all elements of the natural world had a *yua.* When a creature died its immortal *yua* was reincarnated but it would need to be persuaded to come back to life through dances and the use of masks. In the case of this particular mask, it is thought that the bird's *yua* has been possessed by one of the spirits from the land named *Tunghak*. But this is only one interpretation as the story attached to the mask has been lost.

What is a shaman?

The term actually comes from Siberia but it is also used in the arctic regions and on the American continent. The Yup'ik called the shaman *tun-gha-lik* meaning 'owner or master of the *tunghat* (or spirits)'. The shaman was responsible for communicating with the spirit world and specialized in rituals. He was the intermediary between men, the animals they hunted, the spirits and the land. The shaman would experience ecstatic trances, with the goal of re-establishing or maintaining peace within the community. He would also intercede with the spirits so that they might be generous to the group, particularly in providing game which formed the basis of their diet. Once the shaman had succeeded in 'taming' the spirits they would do his bidding, helping him interpret or predict events and granting him access to the spirit masters.

◊◊◊

What were masks like this for?

They were used for certain dances which took place in the *Qasgiq* – the ceremonial 'men's house' in each village. Nowadays they are displayed under artificial lights in museums but back then masks like this would only have been seen by the flickering light of seal oil lamps during very theatrical performances which combined music, singing and dancing. They were either worn over the face or hung in such a way as to allow the dancers to move behind them – as was probably the case with this one since it's over sixty centimetres tall!

How long did these masks last?

These masks would be made in a single day by the shaman himself or by craftsmen following his instructions. They were destined to be used in only one ceremony at the end of which they would be burned. As they contained the spirits they had conjured during the ceremony they were extremely powerful objects. To meet demand for the masks from explorers at the end of the nineteenth century, various tricks were invented to save the real things from being burned. One of these was simply to burn a miniature replica of the mask instead.

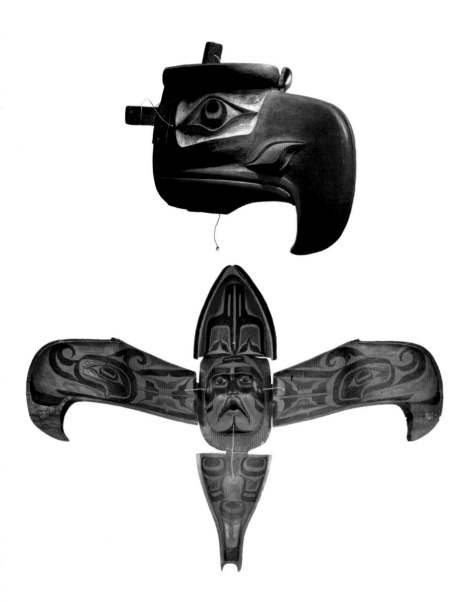

2 Kwakwaka'wakw (Kwakiutl) transformation mask

British Columbia, Canada
Collected prior to 1900
Wood, leather, paint. Closed 62.2 cm, open 143.5 cm
Denver Art Museum, Colorado, USA

Does this mask open and shut?

Yes. It is made up of a fixed part representing a face, and four folding sections attached by thread at the temples, the forehead and chin. When it's closed it is a bird and once opened up it magically transforms into a man. The amazing change in appearance explains why this kind of mask is known as a transformation mask. The bright colours are characteristic of Canada's north-west British Columbia.

What sort of bird is it when it's closed?

It might be an eagle, a crow or a thunderbird – all three are significant in the mythology of the region – but it's difficult to make the distinction without being familiar with how they were traditionally represented. The thunderbird has two kind of horns on its head and a very hooked beak, and the crow's beak is thicker and less curved. This mask has both a hooked beak and a flat head so it is likely to be an eagle.

What do the motifs on the folding sections represent?

They appear to be abstract at first glance, but in actual fact the motifs on the two side sections – painted symmetrically to mirror one another – represent *Sisutl,* a dramatic creature from the mythological pantheon of the Kwakwaka'wakw people. *Sisutl* represented strength and power. Able to take on any form, he could kill and eat anyone who crossed his path. He is depicted by the two profiles on either side of the human face and also by the views from above and below at the top and the bottom folding sections. Apart from his distinctive two-dimensional eye he is recognizable by a spiral-tipped crest on his head and the long curled nostrils.

What kind of wood is this mask carved from?

Like most kwakwaka'wakw objects it's cedar, from one of the most majestic forests in the world. Cedar was used to make immense canoes and huge heraldic masts known as totems. Totems are like community emblem posts and consist of sculptures of animals and humans piled one above another. These posts, placed in front of houses, revealed the high status of the families who lived there.

Kwakwaka'wakw: it's impossible to pronounce!

It is hard for us to say but it really is the name of the Indian tribe and it's pronounced phonetically Kouakouakiaouac. Out of respect for the people it's preferable to use this term – which they themselves use – rather than Kwakiutl

which outsiders have attributed to them wrongly. Kwakiutl is actually the name of only one of some twenty Kwakwaka'wakw groups.

◊◊◊

What is the Kwakwaka'wakw cultural area like?

The north-west coast extends some thousand miles along the coast of North America (from southern Alaska to the north of Oregon). Bordered by the Rocky Mountains and the Pacific Ocean this region is rich in natural resources (forests, wildlife and seashore) so was very attractive for the many Indian communities which moved there between 5,000 and 2,500 years BC, after the last ice age. Those tribes were initially nomadic but they made permanent settlements after the arrival of fish – particularly salmon – which migrate upstream to breed. So to differentiate them from the feather-wearing Indians of the Great Plains (see fig. 3) they are known as the 'Salmon People' or 'Fish-Indians'. Hunter-gatherer-fishermen, they are unique in never having had need for agriculture.

◊◊◊

Who did this mask belong to?

It belonged to a noble or a chief. Kwakwaka'wakw society was very hierarchical with nobles, common people and slaves. Each family unit would have its own wealth, including material possessions (masks, hunting grounds, rivers) and also intangibles such as names, origin myths, the right to celebrate certain ceremonies and dances. The masked dances belonging to a particular family were a mark of nobility and would be inherited by each generation in turn. So the creation of a new mask was fairly rare and the artist charged with making it would enjoy special prestige. His task would be to understand and retell the group's secrets and myths just as western heraldry conveys the tales of our aristocracy.

When would this mask appear?

This mask would make its appearance during the large, highly theatrical winter ceremonies. The Kwakwaka'wakw would spend the six long months of winter in their houses organizing dance ceremonies, holding initiations and marriages according to their social status. The north-west coast is very wet but not very cold and rarely snowy. The Kwakwaka'wakw would gather food during summer, stockpile it in autumn and then devote themselves to spiritual, artistic and festive pursuits during the winter months. We can only imagine the role this particular mask played because – as is so often the case – the dance with which it was linked

has not survived. The descendants of the mythological ancestors would wear masks and costumes during these ceremonies and would re-enact encounters between man and beast and the metamorphoses of animals into humans. This mask would arrive closed, representing the ancestor of the group in bird form. Then, in a *coup de théâtre* at the moment when the song told of the arrival of the ancestor on earth, the dancer would open the mask to reveal the human face. The privilege of attending these prestigious ceremonies was inherited.

Would it matter if the dancer fell over when he was wearing the mask?

Yes it would! Any wrong step by the dancer could cost him a fine. Wearing a transformation mask was a serious task and it wasn't easy; handling such a large one (this one measures 143.5 centimetres wide when open) meant the dancer needed an assistant to guide him and to pull the opening strings. When the mask was open the dancer would only be able to see out of holes in the eyes, or (as here) in the mouth, but he would still have to mimic animal movements and follow very detailed choreography. This mask had a religious role as it rendered visible the supernatural beings of the universe but it also played a social role in proclaiming the chiefs' privileges.

◊◊◊

Are all the Kwakwaka'wakw ceremonies this complex?

Yes. The *potlatch* (meaning 'giving') ceremony from the north-west coast is the best known of them all and was essentially a distribution of goods. The hosts would give gifts to the guests who, by accepting, would recognize the importance and standing of the organizers. The guests would then organize a *potlatch* in turn and would have to give more than they had previously received. So people would accumulate goods with the sole aim of giving them away. The Canadian government felt this represented immoral squandering and banned the practice in 1884. Despite the ban a large *potlatch* took place in 1921. It was to be the last true ceremony of its kind as the government confiscated all the goods concerned (including 500 fabulous sculptures). The indigenous people have recently managed to retrieve them and they are now on display at the Alert Bay and Cap Mudge Museums in British Columbia.

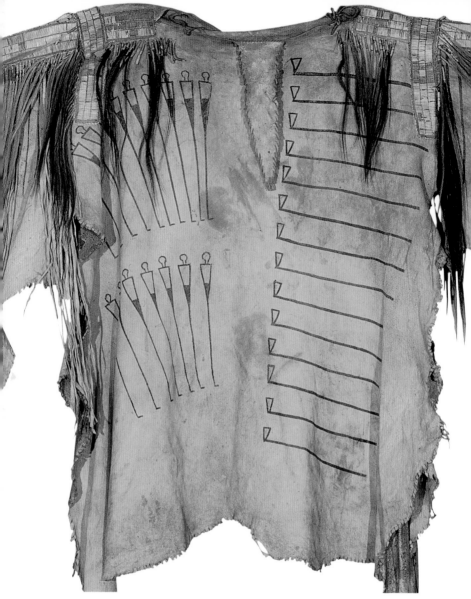

3 Numakiki (Mandan) tunic

Upper Missouri Region, United States of America
c. 1820
Deer and bison skin, porcupine quills, glass beads. Height 82.5 cm
Bought by George G. Heye in Paris and acquired by NMAI in 1929
National Museum of the American Indian, New York, USA

It looks like an Indian costume

This Indian tunic does seem familiar. It is like the ones worn in Westerns by Indian warriors or buffalo hunters in headdresses as they ride across wide open countryside. The prairie Indians in what is now the central US (known as the Great Plains region), are just one part of America's Indian population. For them clothing was used to convey social status as well as being a major means of artistic expression. This tunic was made to honour a warrior in about 1820.

Is it a shirt made of buffalo skin?

No. Buffalo skin was too heavy and thick for a shirt, it was used instead for cloaks and tepees. Making a shirt required the skins of two animals – deer, antelope or mountain sheep – one for the front and the other for the back of the shirt. The hind-quarters of one of the skins would be used for the body of the shirt and the front-quarters would be cut in two to make the sleeves. They can't be seen in this photo but at the bottom of the tunic (front and back) hang the animal's back feet. The overall shape of the animal was retained so as to retain the power of the beast. This tunic was slipped on over the head and hung down almost to the knees, like a poncho.

How was the skin prepared?

Firstly the fur was removed and then the leather was tanned – using a solution made from the animal's brain and liver – until its surface was smooth enough to be painted. Europeans were fascinated by how soft and white the Indians were able to make their leather and it wasn't until the nineteenth century that they managed to match the Indians' expertise at tanning.

What do the painted designs mean?

The warrior would have decorated his own tunic – demonstrating his rank and telling of his exploits and prowess in battle. On the right there are fourteen pipes, represented by parallel lines each ending with a triangle. These correspond to the number of battles the owner of the tunic had successfully fought and indicate that the wearer was the 'pipe carrier' (or leader) at the battles in question. These war pipes, related to the famous peace pipes, were carried into battle as ceremonial objects. The smoke from the war pipes would form a symbolic bridge for communication with the protective spirits. On the left, seventeen enemies killed during battle are shown in a stylized manner – a head and torso on a single leg.

Do all their tunic designs show acts of war?

No. Some have designs which are harder to interpret – linked to spiritual visions, making a connection with the supernatural world or obtaining the protection of the spirits for example. These leather designs act as a sort of collective memory; depicting heroic acts on the battlefield, the visions of spiritual leaders or the successes of famous huntsmen.

◊◊◊

Why does it have fringing?

Fringing like this was common on the arms or backs of warriors' tunics and wrongly earned them the name of 'scalp shirts' (the scalp is a tuft of hair taken from the head of an enemy, with the skin still attached). In fact this fringing is made from leather thongs and hair from a horse's mane. Sometimes locks of human hair were also used, but these were more likely to come from the wearer's family than from enemies. A warrior earned the honour of decorating his tunic with hair only once he had killed an enemy. So fringing like this became a kind of personal display of the wearer's strength, as well as creating a dramatic effect when it moved in the breeze.

◊◊◊

Who made the shirts?

As in most traditional societies, men and women had very distinct roles. The men were warriors, responsible for protecting the group. It was they who dealt with wood, canoes, hunting and so on. The women cultivated crops and took responsibility for food. They also made clothing using animal skins and added decorations using embroidered glass beads or woven porcupine quills (as here on the shoulders and along the sleeves). The quills were flattened and dyed then sewn with bison sinew thread onto fine strips of buffalo leather. Any abstract patterns would be created by the women and the menfolk would then draw on their own figurative designs.

Did Indians wear this kind of tunic every day?

Tunics like this were only worn for public ceremonies, for riding into battle or hunting on horseback. Horses only arrived in the Americas via the Spanish colony of New Mexico and they didn't reach the Great Plains until the end of the seventeenth century. Their arrival was to result in deep cultural shifts for the Indian communities. Thanks to horses the Indians could truly master their

domain and they were easily able to follow the buffalo migrations. But though hunting on horseback was very effective, it also brought with it new conflict as now numerous tribes found themselves hunting in the same territory.

Does this shirt come from a nomadic tribe of buffalo hunters?

No. This tunic is made in a style used by the Mandan people – a tribe of farming Indians from the Sioux language family. They lived by the upper Missouri in North Dakota. The buffalo hunting tribes used to live in tepees – conical tents made by stretching buffalo hides over long poles. But the maize-farming tribes of the prairies lived in houses made of mud, only leaving their settlements for periodic hunting or fighting expeditions.

◊◊◊

Why are American Indians called 'redskins'?

Not because their skin was actually red, but because when they went into battle (and on other occasions) they used to paint their bodies and faces. The natural pigments they used to paint their bodies were also used to decorate their leatherwork.

◊◊◊

Is the Indians' culture still alive today?

Yes, in fact the culture is undergoing something of a rebirth as many Indians are embracing their heritage anew. Indian communities are increasingly getting involved with managing ethnological museums so as to be sure that their culture and heritage are presented accurately.

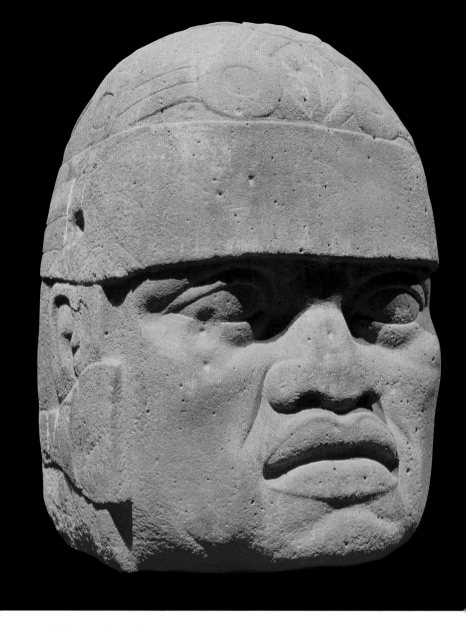

4 Olmec head

San Lorenzo, Veracruz, Mexico
1200–500 BC
Stone. Height 167 cm
National Museum of Anthropology, Mexico City, Mexico

This head alone is as tall as a man!

This head is over a metre and a half tall. About twenty of these heads have been discovered and some measure as much as three metres tall. Sculpted from a single colossal block of stone, these three-dimensional heads are typically Olmec in style. The square face and strong jaw create a very compact shape. They wear a kind of helmet or hat with ear-protectors.

Where is the body?

There never was one. This head doesn't even have a neck and was sculpted just like this without a body. Given how enormous it is, just creating the head alone is a significant feat.

It must be very heavy

Yes, these heads weigh up to fifty tonnes! It is thought that the volcanic rock from which they were made was transported by land and river some thirty miles from the mountains where it is found to the spot in which the heads were erected. All of that would have required huge manpower, organization and energy. The heads would have been commissioned by the Olmecs' priestly ruling class and richly painted according to Mesoamerican tradition.

◊◊◊

Who were the Olmecs?

The name Olmec is given to the civilization which existed between around 1200 and 500 BC in the rubber-producing tropical lowlands around the Gulf of Mexico. The actual name of the civilization is not known so it became known as Olmec which means 'people from the land of rubber'. Though their civilization is not well understood, experts believe that they actually lived in a large part of Mesoamerica (the cultural region stretching from Mexico to the north-west of Costa Rica). Considered to be the first of the major Mesoamerican cultures, the multiethnic Olmecs were followed by the Zapotecs, the Toltecs, the Mayas and the Aztecs. Together these civilizations are known as pre-Columbian and they share cultural characteristics introduced by the Olmecs, including agriculture based on cocoa and maize, sacrificial practices, a divinatory and solar calendar, a ball game on a formal pitch, astronomical observations, numbering and an early symbol-based writing system (which was either painted, modelled or carved), and the construction of pyramids which served as the bases of temples.

Is this head the sculpture of a real person?

We don't know. It's very difficult to answer the questions raised by this sculpture due to the age (1200–500 BC) of the Olmec society. Despite being such a major influence, the Olmecs left behind very little in the way of precise information – even on the imposing monuments for which they were famous. The insignias on the helmets differ from head to head and despite common elements (broad face, large almond-shaped eyes, heavy lids, flattened nose, full lips, mouth slightly open and turned down at the corners) each has an individual expression and personal features, like wrinkles, as though they were actually portraits. The detailed and naturalistic rendering of physical characteristics – including the way the skin sits on the cheekbones and the chin – suggest that these are probably based on specific models rather than being representations of an idealized human form.

◊◊◊

Are there any theories about who they might be?

There is still a huge amount we do not know about these heads. There are many theories – maybe they are representations of dignitaries or warriors who had died. Many believe that they are effigies of real monarchs, that the sculptures would have been completed during the monarch's reign as a symbol of royal power and to render them sacred.

◊◊◊

Where were these colossal heads found?

They were found buried but there is a theory about that too – that they were originally placed on stone pedestals around large ceremonial squares and close to sacred buildings. Olmec life was strongly based around ceremonial centres of military, political, religious and economic power. This particular head was found in San Lorenzo, a major site on the gulf coast that was probably abandoned about 900 BC due to tectonic movement. Around this time several monolithic sculptures were intentionally defaced (with circular grooves) before being ritually buried. We don't know what this 'killing' and burial signified. Could it have been a ceremony performed on the death of a leader or perhaps a rite of passage to the afterworld?

Were the Olmec heads discovered when Mexico was conquered?

No, the first head wasn't discovered until 1862 – well after the conquest which started in 1519. The conquistadors knew nothing about this civilization which had disappeared some one thousand six hundred years earlier, and of which all traces were buried. This first major Mexican civilization was largely unstudied until early twentieth-century archaeological digs.

Did all the Mesoamerican societies make monolithic heads?

No. Whilst other societies (like the Egyptians and the inhabitants of Easter Island) used gigantism, on the American continent it was only the Olmecs who made massive heads like this. But if they do represent monarchs they are evidence of a tradition of leader veneration that was to continue – it also existed it in Mayan culture, for example.

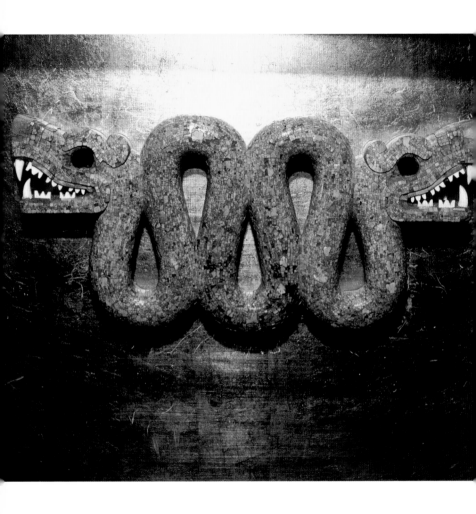

5 Aztec-Mixtec pectoral

Mexico
c. 1400–1521
Wood, turquoise and shell. Height 20.5 cm, length 43.3 cm
Bought with Christy funds
The British Museum, London, England

It's a snake with two heads and huge teeth!

This snake is ready to attack or defend itself in any direction – it has two open mouths full of sharp teeth. The reddish gums and nose make it all the more menacing, but this is clearly a precious and delicate object. The body has been carefully crafted from wood and painstakingly encrusted in a mosaic of turquoise with white and red shells. The wavy form of its perfectly symmetrical body evokes the natural movement of a snake.

Its eyes are empty

Yes. In fact the eyes have been lost. But the British Museum holds a clue as to how they might have looked. The museum also own a human skull set with turquoise and its eyes are shell and polished iron pyrite (a natural iron sulphide which produces golden crystals), so it is thought that this serpent may have had similarly decorated eyes. It would have looked very striking.

What was it for?

As with most Aztec objects it is thought to have had a religious use. Perhaps the loops formed by the snake's body were used to hang it around someone's neck during a ceremony. That person – likely to have been an individual of high status – would then have been imbued with the snake's qualities. The snake is as wide as a man's chest and it would have made any man wearing it look impressive. It offers us a small insight into the way Aztec society was organized hierarchically; with the leading and common classes clearly separated.

◊◊◊

Aren't the Aztecs famous?

Yes they are. They were the last of the major pre-Hispanic (meaning before the Spanish conquest) or pre-Colombian (before Christopher Columbus) societies. The Aztec civilization came into being around 1325 and lasted until it was destroyed by the Spaniards in 1521. When the conquistador Hernan Cortés reached the region that was to become Mexico in 1519 the Aztec society was still flourishing, so there was direct contact (just as the Incas were still in existence when Francisco Pizarro arrived in Peru). Unlike Egyptian hieroglyphs which could not be understood until Champillon deciphered the Rosetta Stone, Nahuatl (the Aztec language) was quickly deciphered and translated by Spanish missionaries like Bernardino de Sahagun and Bartholomé de las Casas. They

studied and in a few cases documented the local customs, so we now have some understanding of Aztec culture. Its religion, art, social, economic and political structures were destroyed by the violent Spanish conquest and replaced by a new, hybrid culture.

Is this two-headed serpent a god?

Although the snake is depicted in almost all of the Mesoamerican religions it was not worshipped by the Aztecs. The Aztecs weren't so much interested in the snake's dangerous and venomous qualities but in its ability to shed its skin – which they interpreted as a symbol of transformation and immortality. The snake became an emblem inspiring the idea of the sacred. It evoked the earth, fertility, vegetation and new growth and was used to invoke the favour of the cosmos and the supernatural powers. Many of the Aztec gods' names contain the word *coatl* (meaning 'serpent') including Mixcoatl (the god of war and hunting). One of the most important gods was Quetzalcoatl (the god of the feathered serpent also known as the 'precious serpent') who was amongst other things the creator god, the god of the wind, life, and fertility, a civilizing hero, and the inventor of maize and agriculture.

◊◊◊

Why is the snake's body covered in turquoise?

The Aztecs demanded tributes from their empire, which included some three hundred and seventy conquered cities. For them turquoise was a precious stone and, it seems, a symbol of royal power, so many of the tributes they received (particularly from the Mixtecs) were in the form of uncut stone or objects (like masks, sacrificial knives or human skulls) covered in polished turquoise mosaic. Was this two-headed snake one such tribute or was it made especially for the Emperor by a court craftsman of Mixtec origin?

The conquistadors must have been blown away when they discovered the Aztec civilization!

To begin with they were. When Cortés arrived in 1519 at the Aztec capital Tenochtitlan (present day Mexico City), it was home to some hundred and fifty thousand people and he described it as 'The most beautiful city in the world, a new Venice [which] few cities of the old world could rival in size or splendour'. But the Spanish were soon horrified to discover the Aztec rituals based on human sacrifice. On the other hand, the Aztecs could not understand the pointless cruelty devoid of religious significance inflicted by the Spanish. It's hard to imagine now,

but a debate raged at the time in Europe as to whether or not the creators of these marvellous Central American treasures (which had started to arrive back in the old world) were indeed human. Did their barbarism mean they should be enslaved or ought their innocence entitle them to be evangelized? In the end it was conceded that they did have souls and were therefore human, but it wasn't until their societies had finally died out that they were studied. From the end of the nineteenth century pre-Columbian art began to be recognized.

◊◊◊

Why did the Aztecs practice human sacrifice?

It was essentially to nourish the world in which they lived and which – according to their myths – corresponded to the 'fifth sun'. The four previous suns (or eras) had been destroyed by cataclysms and while the destruction of the precarious and instable fifth was inevitable, it could nevertheless be delayed by 'feeding' it with human blood.

Human sacrifice and self-sacrifice (spilling one's own blood by piercing the legs or tongue for example) had existed with the same objectives since the Olmec civilization. According to the Aztecs when the gods created the world they had sacrificed themselves to create life, so men did likewise to ensure the continuation of the universe and the daily movement of the sun. Those chosen to die on the sacrificial altar were prisoners of war (notably from the Flower War, conflicts whose aim was to provide victims), slaves, chosen citizens, young children and warriors. In fact it was a great honour to be chosen, as a new life was promised in exchange, depending on the method of death. Contrary to what the Spanish believed, human sacrifice was never gratuitous but always part of a ritual.

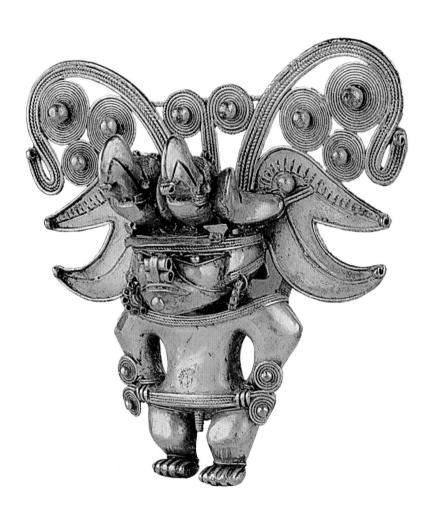

6 Tairona pectoral

San Pedro de la Sierra, Magdalena, Columbia
AD 600–1600
Gold alloy cast in a mould (*cire perdue*). Height 10.6 cm, length 11.3 cm
Museo del Oro, Bogota, Columbia

It's really shiny

This jewelled pendant was probably worn by one of the elite of Columbia's Tairona people – either a shaman (religious leader) or the chief (*Cacique*). These ornaments have mostly been found in tombs and they would have been a means of displaying authority and privilege and of emphasizing the wearer's social status.

He's wearing a huge hat!

At the back of this huge outsized headdress, beneath the swirls and disks, there are two symmetrical birds' heads identifiable by the eye in relief. There are two other birds – eagles with hooked beaks – on the man's forehead. The bird motif is a symbol of the shaman's flight to other worlds and the eagle in particular represents power in the spiritual world. The man's face does look strange, but that is because he is wearing a number of adornments, including nose, ear and lip-rings.

He's very small but he looks full of energy

Yes. He's half crouched down with his hands on his hips and his arms to his sides, his shoulders are hunched and his head is down – everything about his stance suggests a man who is gathering all his strength. This strong, focused posture is great to talk about with kids. Have them imitate him and they will understand why it's widely believed that he is preparing himself for a transformation and that this kind of pectoral represents either the moment of the shaman's transformation itself or his voyage to other worlds.

◊◊◊

What is the facial jewellery for?

According to Tairona beliefs this kind of jewellery helped the wearer to transform himself into a bat. The jewels share the characteristics of the New World leaf-nosed bats with their prominent turned-up noses, growths beneath the bottom lip and flat, sticking-out ears. The empty tubes horizontally across the nasal cavity deform the nose to reveal the nostrils. The labret (a jewel attached through a hole in the lower lip) creates the impression of a growth on the chin and the visor imitates the broad ears. The Tairona men really did wear this kind of jewellery; examples have been found and are now displayed in museums.

Why did they want to transform themselves into animals?

American Indian societies (unlike western ones) often believed that the universe was mutable. They believed that there was no real demarcation between the universe and its inhabitants and no clear distinction between humans and animals. They did not see man as separate from nature, but rather a part of it and capable of passing from one state to another. Objects like this pectoral reflect that view of the world as multi-faceted and of human beings as capable of transformation. With the help of body decorations like painting or jewellery to change the appearance, men were able to disguise themselves and change personality. By wearing a jaguar mask a man could take on a cat's sense of sight. By using jewellery to make his face look like a bat he would become that animal and take on its qualities.

Could anyone transform themselves?

Anyone could change their identity, but only special individuals like the shamans could actually become super-powerful animals such as eagles, jaguars or bats, and only then during special ceremonies. Shamans underwent long training before they could fulfil their role which was part doctor, part astronomer and part wise man and religious expert. It was thought that through fasting, meditation and the consumption of certain (psychotropic) plants they could travel through the universe and meet the supernatural powers which controlled the balance of the world. Where drug use in western countries was primarily about pleasure, there it was about resolving shared problems and trying to maintain the social stability of the group. So the ritualized use of those drugs was closely controlled.

◊◊◊

Why is the bat so important to Tairona mythology?

We know about the bat's importance thanks to the Koguis people, descendents of the Tairona. For them the kind of bat represented here (the only bat in the world to lap the blood of its prey) is associated with the night and with death, but also with life and fertility. This little bat is only found in South America and became known as the vampire bat (*desmondus rotundus*).

How was this pectoral made?

Most of the Columbian artefacts which appear to be made of gold are actually made of alloy. This was cast using the *cire perdue* or 'lost wax' technique, where a mould is shaped around a wax model, which is then melted away. This pectoral is probably a gold-bronze alloy (known as *tumbaga*) which has a lower melting point than pure gold and so is ideal to capture the details sculpted into a clay mould. *Tumbaga* allows for such a delicate casting that there is no need to add any details afterwards. To give the impression of pure gold, any brassiness would have been rubbed away with leaves.

◊◊◊

Was goldsmithing typical of Columbian civilizations?

This pectoral is housed in a Bogota museum called the Museum of Gold! Goldsmithing originated in Peru around 1500 BC and arrived in Columbia in about 500 BC. The pre-Columbian societies of the northern Andes thought that gold came straight from the sun and as it was so indestructible they came to believe it was sacred. At that time gold did not really have any true market value. It only became valuable once it had been made into social or religious symbols like this.

◊◊◊

Is this connected to the myth of El Dorado?

El Dorado was a mythical land in the Americas thought to be overflowing with gold. There, it was believed, a prince covered in gold dust bathed in a sacred lake throwing into it his offerings of pure gold. The Spanish conquistadors thought that El Dorado was located in the Muisca region of Bogota in Columbia and in their lust for gold they plundered thousands of tombs in the area.

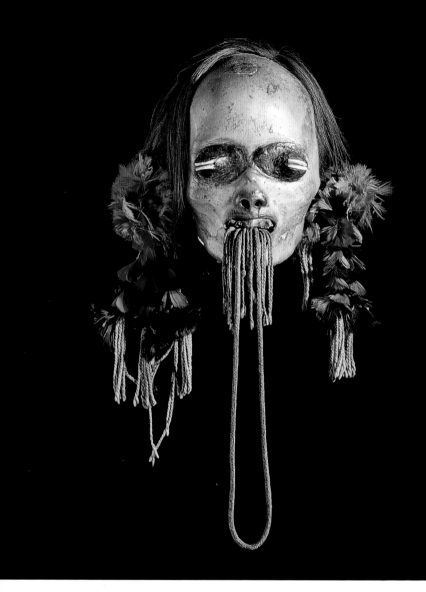

7 Mundurucu head

Brazil
Nineteenth century
Bone, wax, feathers, hair, tapir teeth. Height 43 cm
Anc. coll. Henri Gastaut
Musée d'Arts Africains, Oceaniens, Amerindiens, Marseilles, France

Is this a wooden mask?

Not at all! As fascinating as it is horrific, this is a trophy-head; a real human head. It would have been cut off an enemy and mummified. This skull dates from the nineteenth century and is one of the best preserved of some fifty such known heads from the Mundurucu people of Brazil. You can see the dead man's skin and the head seems strangely alive thanks to the flowing brown hair, the nostrils and the open mouth. The eye sockets have been filled with wax and inlaid horizontally with tapir teeth. Plaited cords fall from the mouth and magnificent feathered earrings hang on either side of the face.

It's disgusting!

We quite often feel unsettled when confronted by a culture very different to our own and we tend to judge that culture particularly harshly when our own seems to contain nothing at all comparable. But the objectification of the dead body has long existed in Europe. For example, for many hundreds of years relics of holy martyrs were conserved in precious boxes (called reliquaries), displayed in churches and venerated. Services were devoted to the relics and people prayed to them for miracles. Just as Europeans displayed Egyptian mummies as works of art, without finding them sordid in any way, so Europeans began to collect mummified heads from the Americas for display in 'cabinets of curiosities'.

Why would you preserve an enemy's head?

The Mundurucu believed that if they killed an enemy they could absorb his energy, so the mummified head of that victim became a symbol of a warrior's strength and the social status he had earned. It seems that the power attributed to these heads was very significant and they played a role in war and initiation ceremonies as well as ceremonies for prosperity and good harvests. The practice came to an end in 1880 when the exploitation of rubber in the area saw Mundurucu territory invaded. The Mundurucu were broken up and their culture permanently destroyed.

Did all the Amazonians have this kind of custom?

No. This custom is not representative of the rest of the Amazonian Indians, but it does remind us of the shrunken heads of the Jivaros (who themselves are probably best known thanks to the book *Tintin and the Broken Ear*). The Jivaros and the Mundurucus used very different techniques to turn their enemy's heads into trophies. The Jivaros (also known as the Shuar) would first extract the skull then cook the head so that it shrunk to about ten centimetres in size. Then, to return it to a human shape they would fill it with hot stones. They lived in the forest on the border of Peru and Ecuador. The Mundurucus lived in the valley of the River Tapajos, straddling three states of current day Brazil, and their method was to keep the skull intact so as to retain its natural proportions.

How was this head created?

First it was emptied, washed, smoked and coated with oil. The head would then undergo three transformations corresponding to three rainy seasons. The first stage was known as 'the decoration of the ears'; where the head would be decorated (like the ones you see in museums) and prepared for being hung by the warrior's hammock and seen by the community. In the second stage the decorations and skin would be removed so that only the skull was left. This would then be displayed in a building reserved for men alone. In the final stage the teeth would be threaded onto a cotton belt and the skull itself would be thrown away. At this third and final stage the trophy would lose all its value. Once this whole process was complete, young Mundurucu men could enter into adult society and become worthy warriors.

It's strange to give your enemy beautiful earrings

The earrings weren't really given to the dead enemy because, as part of its preparation, the head had been granted the honour of becoming a Mundurucu. Decorations made of feathers (propitious for merging with the animal kingdom) were exclusively reserved for the use of men, who would wear them during warrior rituals to display their virility and courage. This was also the case with earrings, helmets, bracelets, knee pads and belts. Far from being adornments for appearance these were a kind of armour which helped the men seize their enemies' power.

Is feather work common in the Amazon?

Amazonian feather work is a major art form – overlooked for far too long. The photograph here does not do the Mundurucu technique justice, but you can see how they would thread multicoloured feathers so densely onto cotton as to give the appearance of velvet. Even nowadays many Indians still use feathers to create sumptuous ritual items.

Are there still Indians in the Amazon?

Yes. At one point there were fears that they would be wiped out by illness but these days they are experiencing a boom in numbers and a cultural renaissance. Some estimates put numbers at between 500,000 and 700,000 in Brazil alone. Most still live a traditional lifestyle but they are not completely isolated from modern Brazil. Neither the image of the 'untouched primitives' nor of people 'contaminated by progress' give an accurate picture.

◊◊◊

Why are the people who live in America called Indians?

Because of Christopher Columbus of course! He thought he was discovering India when in fact he had arrived in the Americas. The term 'Indians' was used to describe the locals and it stuck. Today other terms are used including 'the indigenous peoples of the Americas', 'the pre-Columbian inhabitants of the Americas', 'Native Americans', 'First Nations', 'Amerigine', 'American Indians', 'Amerindians', 'Amerinds', or 'Red Indians'.

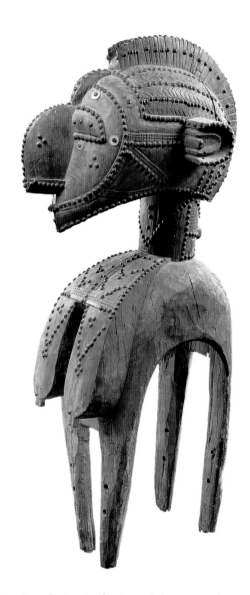

8 Baga, nimba (D'mba) shoulder mask

Baga, Republic of Guinea
Hardwood, upholstery tacks, French coins. Height 135 cm
Anc. coll. Josef Mueller, acquired from Emil Storrer around 1950
Musée Barbier-Mueller, Geneva, Switzerland

What a striking statue. Is it a person or an animal?

The breasts would make you think it's a woman but the enormous nose seems to be a beak. For the Baga (the people who created it, natives of Guinea) there is no doubt it's a bird – the calao.

So it's a woman-bird!

Well, up to a point as this represents neither a woman nor a bird, rather it represents the feminine ideal. For a long time it was thought that this was a fertility goddess. Nowadays the Baga have explained to ethnographers that she is not so much a goddess as a spirit whose job is to ensure growth and fertility. She is the incarnation of life and nature.

She's showing her breasts!

Yes. The breasts are heavy and sagging showing that she is a mother who has been lucky enough to have had lots of children and to have breast-fed them. The generous bust represents female fertility but also the fertility of the earth which provides food. The calao is also a symbol of fertility and growth.

She's got a Mohican

African hair lends itself easily to this style of a central crest and braids at the side – engraved here in the wood. This large head is balanced on a long neck and belongs to a strange body – two breasts on a kind of four-legged bust! The carving is embellished by cuts on the face, neck and chest. Upholstery tacks (used in Europe to attach fabric to chairs and introduced to Africa through trade) are used for decoration, along with French coins.

What is she called?

Nimba is the most common name for this kind of carving but the Baga do not all speak the same language (there are several language groups and we don't know which one this sculpture comes from). Other names such as *D'mba* are also used to describe similar carvings. In the past she would have been given a woman's name to make her unique.

She's got two holes between her breasts!

Yes, they are eyeholes! In fact this carving is a mask used in ceremonial dances. A strong man would slip his head inside, with a cushion to protect him as the mask is very heavy (it weighs about sixty kilograms) and the dance itself would last

for around two hours. The four supports allow it to stand up in the museum but would originally be used to carry the mask's weight on the dancer's shoulders, hence the name 'shoulder mask'. The world of masks includes various types not designed to cover the face: the *heaume* masks are placed on top of the head, in Tanzania there are stomach masks and in the Artic regions there are finger masks.

◊◊◊

Is this mask complete?

No. Most African masks have clothing which is missing here. A hoop of vine would have been passed through the holes at the base of each of the supports and a raffia skirt reaching to the dancer's ankles would have been attached to that. A cloth passed under the breasts would cover *Nimba's* shoulders leaving the breasts exposed. During the dance, the dancer would in effect become *Nimba* so the wearer's identity had to remain secret. It's common nowadays for only the hard part of masks to have survived, as is the case with this wooden one. Masks made entirely of natural fibres or leaves have rarely survived and are therefore rarely seen.

Is the mask ready for dancing?

Nearly. Apart from its clothing *Nimba* is usually accompanied by musicians playing the drum and escorted by women throwing rice as a symbol of fertility. But the mask itself only comes to life with the dancer's steps. In Africa masks like this are only seen during specific ceremonies. When they are not involved in a dance they are hidden from view.

Is the *Nimba* dance beautiful?

Yes. This joyful dance is one of the most beautiful sights for the Baga. The dancer mixes slow, sliding steps with pirouettes, throwing himself almost to the ground and then getting up again. In Africa and among the Baga it's believed that many masks should only be seen by men who have been very specifically initiated. But the *Nimba* mask is not sacred in that way and may therefore be seen by women, children and even by outsiders to the village.

What is the *Nimba* dance for?

It's for many things. *Nimba* is brought out at every stage of the rice-growing agricultural calendar including at sowing and harvest. She supports pregnant women, participates in marriage ceremonies and even accompanies certain

people into the afterlife. The elders may also decide to have *Nimba* dance to honour a significant visitor as they did a few years ago when the President of Guinea visited a Baga village.

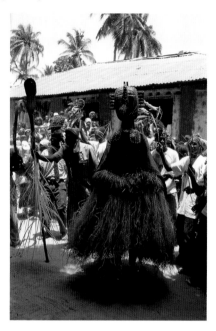

◊◊◊

Do the Baga have lots of *Nimbas*?

Yes. According to tradition, each village has its own *Nimba*. They all have a large head on a long and slender neck, a hooked nose, heavy breasts and four supports. But every artist will try to give their *Nimba* a personality, so some are prettier or more elegant than others. It's interesting to compare them in museums. This one is particularly beautifully made.

◊◊◊

Can you see the *Nimba* dance these days?

Yes, sometimes. Now she is brought out on new occasions, such as the carnival which, since 1989, accompanies the annual football tournament between Baga villages. *Nimba* has become more than a Baga emblem – she has become a national Guinean symbol as she appears on one of the country's banknotes.

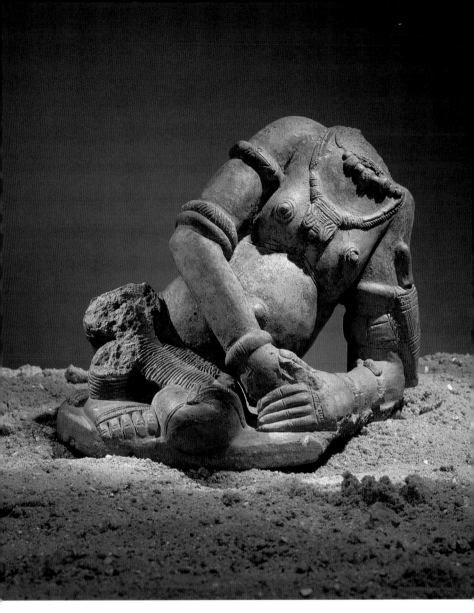

9 Statue from Jenné-Jeno

Mali
Twelfth – fourteenth century
Terracotta. Height 27 cm, length 36 cm
McIntosh dig, 1981
Musée National, Bamako, Mali

How strange to display a headless statue!

This is a very rare sculpture. It's beautiful even though it is incomplete. It's so old that it gives us a valuable insight into the era in which it was created (the twelfth to the fourteenth century).

Before sculptures are displayed in museums they are cleaned and restored and any broken pieces may be stuck back on but if they are unfinished they are never completed. Even the best intentioned attempts would inevitably alter the way the piece was originally meant to be. And in any case, if you did try to finish off a piece you would end up with something that was half ancient and half modern.

Is it a man or a woman?

We don't know. It's fairly common for African sculptures to leave their subjects' sex ambiguous. In the part of Mali where this is from, for example, there are ancestral figures with both beards and breasts. According to myths from the region, in the beginning humans were not divided into two sexes; they only became men or women after many adventures.

◊◊◊

What does this laid-back pose mean?

It's difficult to interpret because it's not a common pose for African sculptures. They usually show their subjects front on, upright and solemn. The finely striped loincloth and the sophisticated jewellery, delicately chiselled and differentiated (nine bracelets and two necklaces), show that this is a high ranking individual. As with other sculptures of this kind there is a dagger in the sheath on the left arm. Is it a warrior? Great care has been taken to portray this individual – the sculpture is clearly the result of a long artistic tradition, signifying the importance of the culture from which it came.

What is this sculpture made of?

It's terracotta – a material that has been used in West Africa (in the deserts near Mali) for some ten thousand years. These days it's used in Africa for everyday objects as well as for sculpture and architecture. This statue actually comes from the Jenné region of Mali, whose terracotta mosque is one of the most prestigious monuments in West Africa. Wood tends to be thought of as the most frequently used material in African art, but that is because it has been so widely used since the fourteenth century and anything before then is unlikely to have survived the African climate. Of course gold, brass, iron, stone and ivory are also used.

Have archaeological digs provided much information on this piece?

This statuette was found in 1981 on the site of Jenné-Jeno, close to the modern day city of Jenné. It has been dated to the twelfth to fourteenth century thanks to other items found alongside it including charcoal and ceramics. Its beauty means it has become a symbol of the site and of Mali's art, history and culture. This kind of work was first identified in the 1940s but wasn't analysed in its archaeological context until the 1970s. Even though pieces such as this are fundamental to building our understanding of Africa's past, very little archaeological research has taken place in Africa, due to both a lack of interest (for a long time people simply didn't believe that there was a past in Africa worth researching) and to a lack of funding. So the majority of artefacts came from illegal digs which aimed not so much to find the remains of past societies as to uncover items that could be sold. This illicit quest for pieces with a decent market value means the ground was inexpertly dug and cannot divulge all the information it contained – once the ground is dug, the information is lost forever. Taken out of their archaeological context many plundered objects will never tell the full story of their cultural or political significance, their usage in daily life or in burial, nor can they enlighten us about the structure or size of the cultures from which they came.

Is this sculpture evidence of the oldest Sub-Saharan African cultures?

No. The oldest finds we know of today are cave paintings found in south-west Namibia and carbon dated to between 25,500 and 27,500 years old. As far as sculptures are concerned, the oldest are the magnificent Nok terracottas from Nigeria, which have been dated to around the ninth century BC. African art is as ancient as European art but since there has only been an interest in it over the last few decades we can assume that we are now only just beginning to discover works which will help us to understand its history.

What is the civilization which created this statue called?

We don't know and because of the lack of written histories from this period in Africa, we probably never will. We know that the urban centres in the region were abandoned around the fifteenth century but though the people who now inhabit the area are descended from the people who made this statue, their way of life has changed so fundamentally since then that all trace of their customs has been forgotten. Still, from the quality and stylistic similarities of the terracotta statues that have been found it has been possible to assume there was a distinct civilization (somewhere between the eleventh and fifteenth centuries). Failing any further information they have been dubbed 'terracottas from the interior delta of the Niger' or more simply 'from Jenné'.

What is the interior delta of the Niger?

The immense Niger River crosses West Africa and just like the Nile in Egypt it has had a profound influence on the history of the whole region. With the Bani (another large river) it forms a network of waterways between Bamako and Timbuktu known as the Niger River Interior Delta. Every year thirty odd square miles of lowlands flood and ancient terracottas have been found on some of the islets which then appear. Quite apart from the very early settlements like Jenné-Jeno around 300 BC, this region has also witnessed the rise of several great empires; Ghana between the eighth and twelfth centuries, Mali from the ninth to the sixteenth centuries, and Songhaï during the ninth to fifteenth centuries. Given its strategic geographic position, the region became a crossroads on the gold trade routes between the Mediterranean to the north (by way of trans-Saharan caravans) and the savannah to the south.

One of the Malian kings, Kanku Musa, made his mark on Europe and the Middle East when he made a pilgrimage to Mecca in 1324 – he distributed so much gold (more than a tonne) in Cairo and in other holy places that he seriously depressed gold prices and threw local economies into disarray for several decades. During the Middle Ages, westerners long admired the sumptuous West African empires with their abundant precious metals and stones. But it wasn't until the end of the fifteenth century that they finally made their way directly to the sources of these riches.

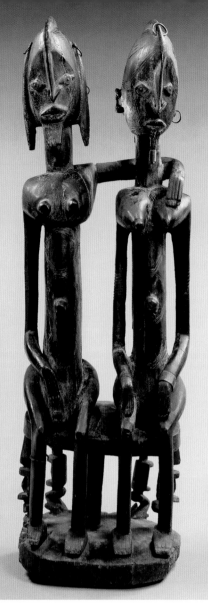

10 Dogon couple

Mali
Sixteenth – eighteenth century
Wood, metal. Height 73 cm
Donation by Lester Wunderman, 1977
The Metropolitan Museum of Art, New York, USA

Are they men or women?

The figure on the right is a man – he's got a small goatee and his left hand is resting next to his penis. The figure on the left is a woman – she has breasts but no genitals. Also, you can't see them in this photo, but the woman is carrying a baby on her back and the man is carrying a quiver. It is customary in some tribes not to wear many clothes, either out of respect for tradition or so as to be comfortable in a hot climate. But even though the figures here are shown naked it doesn't necessarily mean their tribe never wore clothing. The sense of modesty varies from culture to culture and sculpture frequently presents subjects naked.

But the woman has a goatee too!

No, it's a lip-ring – they are worn by the Dogon women of Mali as a sign of high social status. Rectangular in shape, they are made of quartz, cornelian or granite and are attached through a hole in the lower lip. This kind of jewellery is very ancient and examples from the Neolithic period have been found in the Nigerian Sahara. Lip-rings as a custom date back much further than our modern day piercings and have roots all over the world (including among the Indians of Brazil and the Alaskan Inuit) but these days they are worn less and less frequently in Africa. In traditional societies women have their lips pierced not to stand out but to conform with tradition and remain in harmony with their group.

The role of each of the sexes seems rigidly set

The division of labour along gender lines lies at the foundation of traditional societies – the women look after the children, the men provide food, by hunting, for example. Quite apart from the quiver and the baby this sculpture makes the separation of tasks abundantly clear from the figures' poses. The man puts a protective arm around the woman and rests his right hand on the breast with which she feeds her children. His left hand rests on his penis. The poses express how perfectly their roles complement one another in the creation and care of children, assuring the family lineage and the future of their people.

It looks like this sculpture is made of metal

Some African sculptures are deceptive. On the one hand their wooden surfaces have often been treated with substances to colour the wood (just as we use wax polish to protect and nourish our furniture). On the other hand, as a natural substance, wood shows the effects of time, climate and repeated use and wear. 'Patina' is the word used to describe the combined effect of a surface being worked and its natural ageing, but the term can refer to a broad spectrum of finishes from light to dark, and from shiny and metallic to matt and stone-like. In some cases a patina can even be crusty due to an accumulation of sacrificial liquids (animal blood, eggs, oil). But if you look closely at this sculpture you can see the natural colour and grain of the wood, particularly on the pedestal and on the figures' feet.

◊◊◊

They are staring at us

Yes, the eyes are quite striking – they weren't carved out of wood but made from metal rings which were then attached with a nail in the centre to look like the pupil. The jewellery – notably the earrings – is also made of metal.

◊◊◊

The noses are arrow-shaped

Not all Dogon sculptures have arrow-shaped noses, so it must be a peculiarity of a particular Dogon artist (or group of artists). For a long time it was believed that African objects were only for ritual use, so Europeans were convinced that the idea of the artist per se simply didn't exist in Africa. People thought that if the style showed no artistic sophistication and if the creators were adding no aesthetic value then they must be no more than simple, anonymous contractors, craftspeople with no artistic identity of their own. These days research takes into account stylistic differences and can identify individual artists even among the styles of a whole tribe. As with medieval European artists, when the hand of a particular sculptor has been identified, but his name is not known, he is referred to as 'Master of . . .' followed by the name of the village where one or more of his works come from.

Why have they both got big belly buttons?

Many African sculptures have huge belly buttons (sometimes known as an umbilical hernia). They are a symbol of a mother born of a mother and represent the body's centre of energy as well as underlining the importance of family links. Many different societies attach metaphorical significance to the navel; in the sculptures of the Songye people from the Democratic Republic of Congo they represent the ancestors as the source and the protectors of the family.

Do the real Dogon people look like these figures?

No. These aren't portraits but a stylized, idealized representation of humans to which the artist has added very precise and realistic Dogon adornments including the jewellery, scarification and hairstyles.

◊◊◊

The seat is being held up by four small figurines

According to Dogon mythology the two disks linked by a central pillar and forming a stool represent the earth and the sky which are linked by a tree, the axis of the world. Around the edge, supporting the seat with their heads, are four small standing figures representing the ancestors in their role as support to the living. According to legend, the creator god, *Amma*, made four pairs of twins (known as the eight *nommo)* and these are the original ancestors, which often appear in sculptures.

◊◊◊

What was this sculpture for?

Even though the Dogon are among the most studied of non-European civilizations we don't know what purpose this sculpture served. The research we do have focuses on Dogon mythology and social structure but there is very little about their art. More is known about the (public) uses of masks than about statues which were used in secret. But one fact can help us in interpreting this sculpture; from its smoothness and the absence of sacrificial matter it's likely that this couple were not used on an ancestral altar but more probably displayed during funeral ceremonies.

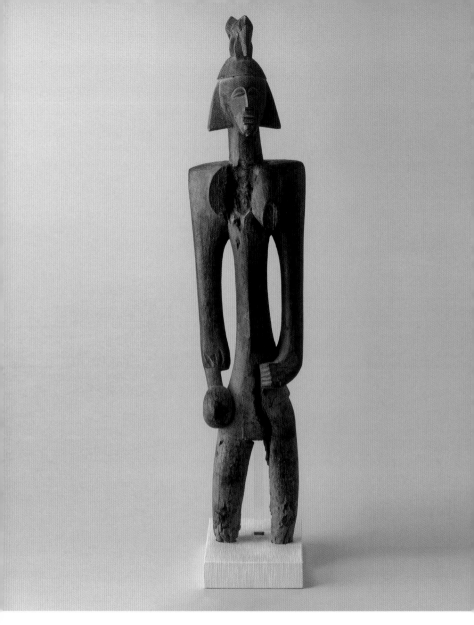

11 Senoufo deble (or pombia) statue

Ivory Coast
First half of the twentieth century
Hardwood with a brown patina. Height 102 cm, length 25 cm
Musée du Quai Branly, Paris, France

What a very stiff pose!

It almost looks like the statue is standing to attention. The figure seems very masculine with its rigid posture, severe expression, stiff jaw and square shoulders, but the presence of the right breast (the left one has been gnawed by insects) indicates that it is in fact a woman.

Why are her arms just dangling down?

This pose was probably dictated by the shape and size of the wood used: a tree trunk with a diameter of about thirty centimetres and at least a meter in height. Most African sculptures were made, like this one, from a single piece of wood and rarely take a very broad stance.

◊◊◊

The artist hasn't bothered to show lots of detail

No, the artist has simplified the body; the fingers are only suggested by grooves in the wood and the wrists and elbows aren't shown at all. But this simplification is far from being an easy way out or covering up a lack of talent; it's very consciously done. Unlike the Greeks or artists like Michaelangelo, African artists rarely try to mimic nature with exact representations of every muscle or vein, rather they aim to show the essence and the expressiveness of their subjects. This is done by creating simple, stylized, refined, or even geometric shapes.

(Try drawing the outline of this statue with children, including the elegant spaces created by the arms. Kids will be struck by how symmetrical – architectural even – the sculpture is.)

◊◊◊

It's really damaged

Yes. It only dates from the early twentieth century but it has been prematurely aged by insects, like termites and worms; a breast is missing and she has no feet. Nowadays a procedure known as anoxia can be used to get rid of any insects or larvae in organic matter like wood, feathers or leather without harming the objects themselves. The object is sealed in a special box from which all the oxygen is then removed, making it impossible for anything living in it to survive.

It's big!

At over a metre tall there are very few African sculptures as large as this one. That is because most African sculpture was not designed to be on display in the open but rather for use, sometimes secretly, indoors. On the other hand, masks designed for dancing out of doors can reach enormous sizes. The Dogon people in Mali have masks as large as ten metres high!

Is she for decoration?

No. She wasn't made as an ornament but for ritual use. Which isn't to say that she could get away with being ugly. Senoufo sculptors would train for seven or eight years before being allowed to make ritual items and aesthetic research was an important part of their training.

◊◊◊

What is initiation?

It is a fundamental rite of passage in many communities which allows a person access to the knowledge and status of adulthood. The ceremonies differ throughout Africa but for boys they generally involve a period of seclusion with others of a similar age group. For girls initiation is usually much shorter. Qualified adults will pass on to these youngsters the cultural knowledge and moral, philosophical and religious precepts they need to become adults, to become full members of their societies, able to marry and communicate with the spirits. Different societies have different stages to their initiations into adolescence, adulthood and even to becoming a sage. They represent a kind of education and even have their own set of tests designed to confirm what has been learnt.

What about Senoufo initiations?

The Senoufo people have a very ancient initiation process for those entering manhood (the initiation of women is less important to them). It takes a total of twenty-one years, divided into three stages of seven years each (boys – and in some societies girls – are often circumcised as part of the initiation process). At the end of the final stage (itself subdivided into twelve steps) the individual attains the status of 'wise man'. Each of the three stages is a sort of metaphorical death of the person who enters the sacred forest and is reborn into his new state when he returns. This rebirth is sometimes accompanied by a change of name. During the initiation sculptures are used by the teachers and masks are used to celebrate each emergence from the forest.

What role would this sculpture have played in an initiation?
This kind of sculpture is known as a *deble* or *pombia* (they are sometimes made from the Senoufo's holy wood, the *poro*). At the end of the initiation and at the funerals of major initiates they would be beaten on the ground to the rhythm of the dances. Unfortunately this one has lost its characteristic bottom section which would have been a large cylinder.

Do the Senoufo have a creation myth?
All peoples have their own mythology. According to the Senoufo the creator god first made the five ancient beasts: the python, the tortoise, the calao bird, the chameleon and the crocodile. He then created the first human couple who in turn created the rest of humanity. This sculpture represents the female half of this original couple.

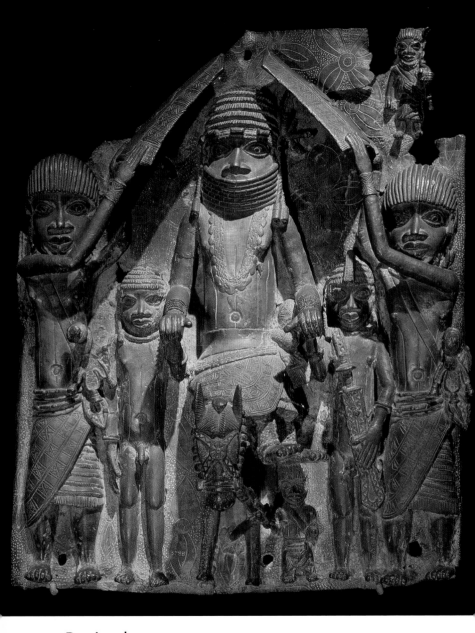

12 Benin plaque

Kingdom of Benin, Edo tribe, Nigeria
Seventeenth century
Brass. Height 51 cm, length 37 cm
The British Museum, London, England

There are lots of people!

Firstly there is the king on horseback (a symbol of his power). He is symmetrically framed by several others. There are two slightly smaller warriors who are protecting the king's head with their shields and two assistants, who are smaller still, holding his hands. The assistants appear to be standing behind the king and the warriors. Of course the dimensions are not accurate; the people aren't shown according to their actual size but according to their place in the kingdom's hierarchy: it is easy to see that the central figure is the most important. Finally there are two other figures which are so tiny as to be almost hidden; one is at the top and one at the bottom.

Who is the king?

This brass plaque includes the royal insignia but it's not clear whether it is meant to represent a particular king or the role of kingship more generally. What we do know is that it is a king (*Oba*) of Benin – that's the name of a kingdom within Nigeria, not the country Benin.

How does one recognize an *Oba*?

Though the only clothing he is wearing is a loincloth, the Benin *Oba* is recognizable from a number of symbols (not all of which have a clear significance); his impressive headdress and the necklace covering his mouth, the other necklace on his chest, the bracelets at his wrists and the shields sheltering him from the sun. Headdresses and high necklaces like this are usually reserved only for kings or with the king's express permission, high dignitaries. In real life the necklace would be made of many rows of red coral beads.

◊◊◊

What do the coral beads symbolize?

The king had strict control over the trade of all coral and anything made of metal, ivory or leopard skin. Coral beads were a sign of wealth and a symbol of the king's mystical power. They contained the life force transmitted to the king by the god of the sea and they had the power to turn words into reality.

There are some flowers with four petals

These are actually the leaves of aquatic plants used by the priestesses of *Olokun* (the god of water) in certain healing rituals. Just as medieval paintings used a golden area to represent the divine space so these leaves evoke the richness and abundance of the divine.

Was the Kingdom of Benin significant?

Yes. The kingdom carried the name of its capital, the modern day Benin City in southern Nigeria. It was founded around 1100 to 1200 following a revolt by the Edo people against the Ogiso dynasty that had itself been founded around 900. The King of Ife, a neighbouring sacred city, was asked by the Edo to provide them with a new king. But the King of Ife was not sure how the Edo would treat his son so for seven years he sent seven fleas instead. As the Edo people looked after them well, he finally sent them his son Oranmiyan who married an Ogiso princess. Together they had a son, Eweka, who became the first *Oba* of the new dynasty. The current *Oba* is the thirty-ninth to hold the title and according to the legend is a direct descendant of Oranmiyan like his predecessors.

What were these plaques for?

According to European explorers who visited the Kingdom of Benin, the *Oba*'s palace was decorated with many plaques like this as a means of displaying his power. The three holes visible at the top and the bottom of the plaque would have been made by nailing the plaques to the palace's wooden pillars. Known as 'Benin bronzes' most of these plaques were actually made of lead brass (an alloy of copper, zinc and lead). Brass wasn't chosen by accident – it doesn't rust so it evokes the permanence and continuity of the kingdom.

Who made these plaques?

Huge kingdoms existed in Africa before European colonization in the nineteenth century. Benin art is royal art whose aim was to express and legitimize the grandeur of one of those kingdoms. So special artists were required to work solely for the king. They were organized into sorts of guilds and had their own quarters in the royal compound.

How did this plaque end up in the British Museum in London?

In 1897 Britain wanted to control the trade of palm oil in the region so they hoped to sign a protectorate agreement with the King of Benin, Ovonramwen. The king made it known that he was unable to receive the British as he had to attend his own deification ceremony but they ignored this and turned up at his palace anyway. Fearing war (and unbeknown to the king), two of the palace chiefs arranged an ambush in which all but two of the British contingent were killed. In response, the British dispatched 1,500 men on a 'punitive mission' to plunder the *Oba*'s palace. The *Oba* refused to co-operate and went into exile where he died five years later. Thus ended the autonomy of the kingdom. Some of the 2,400 ivory and bronze items taken on that occasion are now found in the British Museum in London.

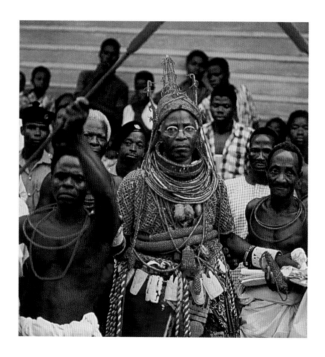

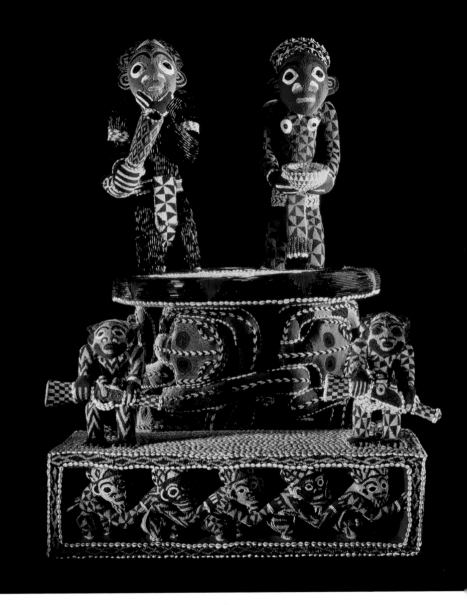

13 Mandu Yene Throne of Bamum King Nsangu

Kingdom of Bamum, Foumban, Cameroon
Third quarter of the nineteenth century
Wood, beads, cowrie shells, fabric. Height 175 cm
Gift from King Njoya, 1908
Museum für Volkerkünde, Berlin, Germany

It's very colourful!

There are so many colours that you don't immediately notice what this object is, embroidered with an abundance of multi-coloured beads and white cowrie shells. Then looking more closely you see that the two standing figures form the back of a seat overhanging a footrest. The footrest is watched over by two men armed with rifles and their base is decorated with a frieze of five figures. On the seat itself there is a cutaway design of two intertwined serpents with monumental heads – a symbol of royal power. The whole thing is a throne described as *mandu yene*, meaning 'richly beaded'.

How are the beads and shells attached?

They are sewn onto fabric which is fitted tightly over a carved wooden frame. The royal sculptor would have had to have found a huge tree trunk at least a metre in diameter for the frame. No doubt he used the same tree for the footrest. Rough-hewn in the forest the two sculptures would then have been finished at the palace by an expert, royal bead-worker.

◊◊◊

Did all kings have such impressive thrones?

No. At one metre seventy-five centimetres tall, this one was made especially for King Nsangou, who ruled the Kingdom of Bamum (in modern day north-west Cameroon) between 1860 and 1885. The region is known as Grasslands or Grassfields and is made up of distinct political units (known as chiefdoms or kingdoms) each of between a few hundred to several thousand people. Bamum was the largest kingdom in the area with some three hundred thousand inhabitants and its art, referred to as *Bamikele,* is very well known.

Does the kingdom of Bamum still exist?

Yes it does. Its current king, Mbombo Njoya, was crowned in 1992 and he is the nineteenth of the Nshare dynasty which was founded around the seventeenth century. He is the great grandson of this throne's owner and succeeded Seido Njimoluh Njoya, Nijoya and Nsangu. Before coming to the throne Mbombo Njoya held several ministerial posts. Modern Cameroon's borders were decided by western colonial powers and do not take into account the history or reality of the ancient kingdoms, but nevertheless the kings and chiefs of western Cameroon have been able to retain their power and influence at the heart of their nation's politics.

Is this throne part of the Cameroonian crown jewels?

Of course. Grasslands art is very politicized and often used as a symbol of the chiefs and kings. The crown treasure is kept in a kind of private museum within the compound where the king and his family live (in Bamum's capital this is known as the Palace, elsewhere as the *Chefferie*). The treasure consists of statues of kings and queens, of thrones and other objects used in traditional ceremonies.

Do they often cover carved objects in beads?

No. Beads were considered precious and were therefore only used by the king. When the European colonizers tried to sell beads to the Bamileke people they were surprised at how sophisticated demand was – the locals would request, for example, Venetian chevroned beads in Murano glass. It turned out that Arab traders had long been importing European beads across the desert. Beadwork is fairly rare in Africa but is common not only among the Bamileke in western Cameroon but also among the Nigerian Yoruba and the Ndebele people of South Africa.

Why were cowrie shells (which could be gathered on the beach) used as money?

Although these little shells were very plentiful in the Indian Ocean they were not found on West African beaches! They were introduced to Africa by Arab traders and for many years before the arrival of western currency were rare enough to be used as money. Their abundance on this throne and footrest were proof of the kingdom's wealth.

The two figures don't look like each other

Each of the poses and the symbols used has its own meaning – each of which has been interpreted in all kinds of ways. The figure whose chin is resting on his left hand is thought to be either a servant or a twin. Twins were believed to have supernatural powers, so they were just the kind of person any king would want to have around him. The experts don't agree on this interpretation because the gesture differs slightly from the traditional one of subservience – where one speaks to a superior either with the hand in front of the mouth or with the left hand on one's chin and the left elbow in one's right hand. Some think the gesture might be evoking the king's wisdom as he contemplates his responsibilities. The figure on the right (it isn't known why it has a red face) is not thought to be the other twin but the queen, recognizable from her breasts, her long skirt and her offering cup.

Did the king use this throne every day?

No. This throne was reserved for important occasions like the coronation ceremony during which the new king would sit on his predecessor's throne. He would later have a throne of his own made to characterize his own reign which would be used in turn for his son's coronation. Only the king had the right to sit on this most imposing and magnificently decorated of seats. Others would be allowed to sit on simpler seats depending on their status, or to sit on the ground or alternatively to remain standing.

◊◊◊

Why is King Njoya so famous?

King Njoya was an exceptional monarch. Early on in his reign, around 1885, he invented a pictographic script which made him extraordinarily famous. He had seen the writings of the *Qur'an* and was impressed by the perspectives that writing could bring, so he wanted such a system that would be understood only by him and those close to him. He had the history of his country written down in what was one of the few scripts to be invented in Sub-Saharan Africa. That system is still taught to this day.

◊◊◊

Where is the throne now?

The throne is now one of the prized exhibits of a museum in Berlin. Njoya gave it to the German Kaiser Wilhelm II in 1908 as a gesture of thanks. The Germans had recovered the skull of his father King Nsangu from a neighbouring tribe thus allowing Njoya to honour the deceased king's memory in the appropriate manner. It was customary to present other chiefs and kings with gifts to seal a friendship or secure allegiance, so presenting such a prestigious and symbolic gift clearly signalled Njoya's desire to co-operate with the colonial power. In fact, the Germans had signed treaties with the Atlantic coast chiefdoms as early as 1884 so they actually already owned what was to become Cameroon. It appears that King Njoya had a copy of the throne made for the treasury which explains why there is a very similar throne on display in the museum in Fumban. But experts disagree as to which is the original and which is the copy!

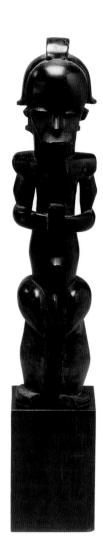

14 Fang reliquary figure (éyima biéri)

Gabon
Nineteenth century
Wood, bronze, palm oil. Height 67 cm
Anc. coll. Alberto Magnelli. Gift from Susi Magnelli 1984
On loan to the Centre Georges Pompidou, Musée National d'Art Moderne, Paris,
France. Displayed since 2000 in the Pavillion des Sessions, Musée du Louvre, Paris,
France

He looks so calm

This figure looks very serene with its straight back and eyes half closed. He is holding a small container resting on his stomach. He is naked and you see his penis straight away so the artist obviously wanted us to know it's a man.

The sculptor has forgotten some of the features!

It's deliberate. He has carved a curved forehead, eyes and a nose but the mouth and chin merge into one another as if the sculptor wanted to simplify the lines. The buttocks and thighs are a single block with a protruding knee echoing the nose and the penis in its pointiness. Plus he is managing to hold a pot even without any hands! It's not a real human being, so he doesn't have to be perfect.

Is it varnished?

The Fang people who made this sculpture prized polished items particularly highly. First the item would be soaked in silt or brewed-up roots to darken its colour. Then some items would be given a second treatment with a mixture based on palm oil and *bois rouge* sawdust, crushed bark, resin or charcoal. Usage would then give the items their final patina as blood, palm oil or other substances would often be applied during formal ceremonies. This sculpture is so shiny because the Fang believed in the purifying qualities of palm oil and by coating this sculpture in it they hoped to strengthen its powers of intercession.

◊◊◊

What was this sculpture for?

This sculpture was the guardian of the ancestors' relics. The Fang people believed that their ancestors' spirits were held in their bones. When they were forced into migration, honour demanded that they carry their forefathers' bones with them, so when they moved, families would take bark reliquaries holding the ancients' skulls and teeth, as well as things like seeds and medicinal plants. A thin wooden fastening rod runs down the statue's spine and then fits neatly into a specially made hole on the lid of the reliquary. The figure would be crafted so as to fit either seated at the edge of the lid or standing on the box itself (as with this one). The term *biéri* is used to refer to the box and the figure as well as to the practice of ancestor veneration. On its own the statue is called an *éyima biéri* or 'ancestor figure'.

Since they guarded such precious reliquaries did the figures have to be perfect?

It was crucial! For the Fang, a reliquary figure represented all the ancestors whose physical remains were enclosed in the box. The figure's power would come as much from its form as from its usage, so it had to be not only elegant but to represent the diversity of human form from a tiny newborn (with its large head, large navel and rounded stomach) to a full-grown man with muscles and genitals. Reliquary figures might share common elements such as the straight back and the bent knees but striking differences in style also prove how highly the Fang valued artistic skill. They would sometimes make very long journeys to commission reliquary figures from renowned sculptors. Westerners have seen the beauty of this particular figure as a yardstick for African art since the 1910s.

◊◊◊

Is the worhip of relics common in Africa?

As a custom it is particularly strong among tribes in the region where the Fang live (southern Cameroon, Equatorial Guinea and Gabon). In Equatorial Africa the ancestors are often seen as mediators with the spirit world. Though they all perform the same task many of the reliquary figures in the region take very different shapes.

◊◊◊

What sets the Fang ancestral cult apart?

Prayers and sacrifices of the *biéri* cult were offered via the intermediary of the ancestors' skulls to invoke the survival and the protection of the lineage. So the veneration of ancestors played a key role in deciding, for example, where to plant new crops, in identifying the causes of an illness or in initiating a hunt or a war. The *biéri* would grant prayers and warn of danger. Men who had been specially initiated would see and hear the ancestors in dreams or after taking hallucinogens (*alan*). The *éyima biéri*'s role was to protect the relics from harmful influences. The *biéri* cult was probably outlawed by colonial authorities in the 1920s and 1930s but it later re-emerged in syncretic form (merged with Christian rituals) under the name of *Bwiti*.

Why did Alberto Magnelli buy this sculpture?

Like other artists at the beginning of the twentieth century, including Picasso, Vlaminck or even Matisse (who started collecting sculptures like this in 1906), the painter Alberto Magnelli (1888–1971) had a significant collection of African art. He said 'I particularly love the powerful formal beauty and inventiveness of negro art. Of course I'm also interested in what these masks and fetishes mean, in how they are used, in their magic, but all of that is secondary to how sculptural they are.' Though it was figurative, African art's stylization and freedom opened up huge possibilities for western artists seeking alternatives to naturalism and longing for a new creative vocabulary. African art had no directly discernable influence on Magnelli's abstract work, but it must have fed his imagination just as it inspired the Fauves and the Cubists.

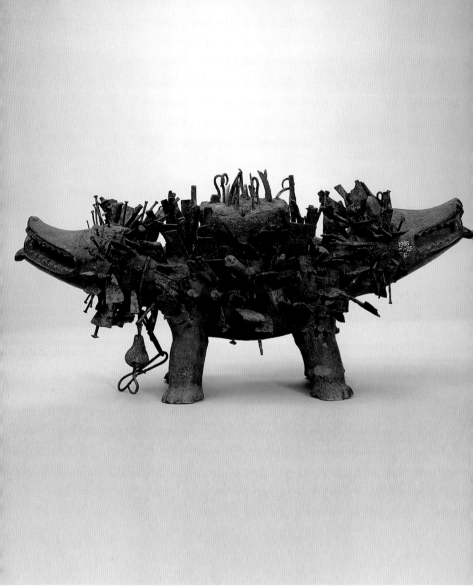

15 Double-headed Kongo dog

Kozo
Democratic Republic of Congo (formerly Zaire)
Late nineteenth century – early twentieth century
Wood, metal (iron), resin, plant fibre and bone or ivory. Height 28 cm, length 64 cm
The British Museum, London, England

A two-headed animal!

Yes, it's a strange dog with two heads, both open-mouthed and both with their tongues out. It's symmetrical – at both ends the animal has its feet and its heads in the same position. It's as though the artist simply carved half a dog and then copied it. Its fur is made of various metal objects attached to the wooden body including nails, knives, miniature hoes, needles and spikes with their ends curved over. They give the creature a strange and aggressive appearance. This is a very sophisticated and well-proportioned piece as we can see from the attention paid to the angle of the two heads: they are slightly lifted so that the two mouths align with the gently curved stomach.

It's scary!

Maybe children like this kind of sculpture precisely because it is scary! It certainly seems familiar and resonates with us to the point where our imaginations take over and we start to believe in magic again. Nail sculptures are often wrongly associated with sorcery but these statues were actually thought to control benevolent forces as much as evil ones. On the one hand they could be used to bring about illness but on the other they could be used find the cause and the cure. These sculptures were used to help identify thieves, track witches, resolve marital problems and warn of attacks by wild animals. In short these were seen as objects with limitless power and as such were very much revered.

Why is his fur made of metal objects stuck into his body?

First the *nganga* (a medium and ritual expert) would insert as many blades as he needed to awaken and capture the forces required to seal an agreement (a military pact, a land-sharing agreement or the settlement of a dispute), to heal physical or mental illnesses and particularly to crush enemy witchcraft or even capture enemies and sorcerers. If peace had been disturbed by a third party the *nganga* would act publicly to try and control the negative forces and re-establish harmony. This kind of sculpture is not limited to the central African region. In many other places (Africa, the Americas but also Europe) there is a popular belief that using figurines like this, sticking them with needles, would put a spell on your victim.

So is it a 'nail fetish'?
The term 'fetish' was borrowed from the Portuguese in the sixteenth century and used to describe objects pertaining to a cult that are also called idols or *grigri* in Africa. It is not strictly accurate to refer to this sculpture as a nail fetish, nor is it very respectful of the beliefs involved, and as such the term is now not generally used by researchers.

◊◊◊

The dog has a big hump in the middle of his back.
To increase the sculpture's strength the *nganga* would place medicine there. That medicine would comprise secret substances such as sacred plants, soil from the cemetery, seeds, hair, teeth, nails, stones and porcupine quills. So the hump is a receptacle housing the statue's power (*bilongo*). When the cavity is empty (as is the case here: it was probably emptied by Europeans when they acquired it in the early twentieth century), the statue is effectively powerless. In human or animal figures the *bilongo* was often found in the stomach or head. It made each statue unique, allowing it to act in the name of the *nganga*.

◊◊◊

Why choose a dog to resolve problems?
Many civilizations have accorded special significance to dogs. The ancient Greeks believed that Cerberus, a three-headed dog, guarded the entrance to the underworld. For Kongo people the dog was a domestic animal with superior powers – a mediator between the living and the dead. Even a normal dog can smell and see much more than humans can (out hunting for example a dog can locate the prey when man can neither see nor smell it). These powers would be doubled in a dog with two heads and four eyes and he would therefore be able to see into invisible worlds (where the ancestors dwell) to track sorcerers (*ndoki*) and destroy evildoers.

◊◊◊

Why do they both have their tongues out?
Some children might think that the dogs are preparing to bite. But in fact they are panting. According to the Kongo, when the *nganga* sent a dog into the invisible parallel world it would swallow negative energy which it would then have to spit out.

How can the *nganga* tell whether his dog is travelling in another world?
Probably by using the object that is hanging around one of the necks. It's difficult to tell what it is in this sculpture but in other similar Kongo sculptures the dog is wearing a small bell. Just as kongo hunters would put bells on their dogs so they always knew where they were in the forest, so the *nganga* would give his helper a bell so that he could tell where he was in his spirit-journey.

◊◊◊

He's called *Kozo*
That's what this kind of statue is called in the western part of the Democratic Republic of Congo. For the Kongo people *kozo* means 'scream of terror' and probably comes from the frightening belief that when the sculpture comes to life each deadly nail would start to shoot out like a bullet from a gun. But the more general name for this kind of sculpture is *nkonde* or 'nail sculpture'. Any sculpture containing a magical charge and capable of receiving a dead spirit is known as an *nkisi*. They are not always figurative. In fact it was much more common for them to be simple clay pots or glass bottles rather than carved human or animal figures, but of course these were much less prized by collectors.

Are there nail sculptures all over Africa?
These sculptures are typical of Congo and the Democratic Republic of Congo but they are the result of very ancient beliefs. In his 1668 work *Description of Africa* Olfert Dapper writes of 'nail fetishes' in the coastal kingdoms of central Africa.

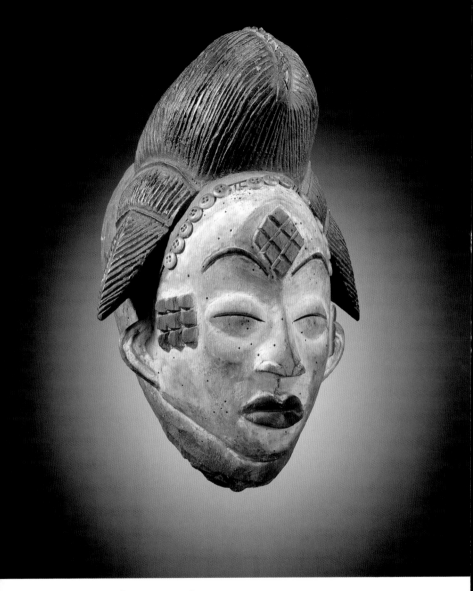

16 Punu Okuyi Mask

South of Gabon or south-west of Congo
c. late nineteenth century – early twentieth century
Light wood, white (kaolin), brown and black paint, buttons. Height 29.5 cm
Anc. coll. Joseph Mueller, acquired before 1939
National Museum of African Art, Smithsonian Institution, Washington, USA

This face doesn't look very African!

This mask really is African, though at first glance you might think that it comes from Asia. The half closed, almost almond-shaped eyes, the pale skin and the black hair pulled into a sophisticated topknot, are reminiscent of a Japanese Geisha or a Noh theatre mask. However, the use of make-up (lips painted red and white skin), the eyebrows which appear plucked and the eyes with no visible pupil are typical of the Ogooué River Basin region in Gabon. Most masks from this region reflect an aspiration to refinement and delicacy. This mask is particularly elegant due to the hairstyle – set with buttons at the hairline – and the remarkably detailed decorative lozenges on the forehead and temples.

How would this mask have been worn?

It would have been worn on the face by a dancer who would hold it in place by biting down on a small piece of wood fixed to the inside. Dances were performed on stilts of up to two metres high and with the dancers' bodies hidden behind a fibre or cotton costume. A mask like this must have been quite a sight to see – like a giant looking down from a great height, setting himself apart from the people below.

Does white mean something special in Africa?

In Equatorial Africa 'white masks' such as this (so called because of the white pigment with which they are covered) come in all shapes and sizes. In that region white represents death, the spirits and the invisible world but it doesn't hold the same significance elsewhere in Africa, or elsewhere in the world for that matter. In other regions, for example, white is used to evoke fruitfulness or purity.

What do the decorations on the forehead and temples represent?

They represent scarification typical to the region. The skin is deliberately cut and then the scarring process is managed so as to produce a design. The symbolic meaning of these designs is not well understood, but they probably acted as a kind of adornment; like make-up or jewellery. The information gathered by ethnographers is contradictory, but according to some scarification was reserved for women, so it is thought that this mask represents a female face. The nine shell blocs placed in a diamond shape on the forehead speak of origins in the south-west of Gabon and recall the nine ancestral clans which govern marriages. One of the key things about masks like this is that they were made and used by different ethnic groups such as the Punu and Lumbo.

Is scarification something specifically African?

No. Altering the body's appearance for more or less aesthetic reasons is practiced in Africa and elsewhere in many different ways, including tattooing, painting, hair-removal, male and female circumcision or the filing of teeth. Though scarification may be more frequent in Africa, it also happens in Oceania, for example. Apart from the aesthetic aspect, scarification can provide information about the status of the individual such as whether or not they have reached puberty, whether they have come of age or if they belong to a certain group. Scarification may also be designed to protect or to make the wearer more attractive. This kind of adornment is permanent and it has tended to die out as more and more people moved to towns and cities, leaving historical traditions behind and leading increasingly cosmopolitan lifestyles. It's ironic that some Africans living in the West have regretted their own scarification marks whereas westerners have actually invented their own types of body art including piercings and tattoos.

◊◊◊

What a good hairstyle. Could you have that for real?

Of course; hairstyles can be very sophisticated for both African women and men whose hair naturally lends itself to styling like this. Just like scarification, hairstyles served not only to make the wearer more attractive but to convey their status. This elaborate style was very fashionable among Punu women of the nineteenth century and many are also shown wearing it in early twentieth century photographs. This mask shows the most up-to-date version of the style, consisting of a kind of large central crest (created by teasing the hair upwards onto a fibre hairpiece) with a single plait on either side of the face.

◊◊◊

Is the mask as calm as it looks?

With its serene and inscrutable expression this kind of mask represented the spirits of death and was used at public events such as funerals, the end of a mourning period, healing ceremonies or criminal judgements.

The dance was really a spectacle for men who had come of age – women and children might sometimes dare to watch from a distance. The uses of this kind of mask remain somewhat unclear: some authors mention frightening apparitions and terrible screams; others think that they were used to placate the spirits of virgins who had died prematurely. In that case the mask would seem to represent the face of an idealized woman – maybe one who had returned from the land of the dead.

Are these masks still used for dances in Gabon?

Masks that look like this are still much loved in Gabon and worn for fun in masquerades. Though they were originally used for rituals their significance is now primarily cultural.

Is this kind of mask well known?

The delicacy and simple lines of the Punu masks has made them a favourite with Europeans since the early nineteenth century. At auction, beautiful examples have been known to fetch record prices – in 2001 a Punu mask from the private collection of Hubert Goldet was sold for US$440,000 (£298,000).

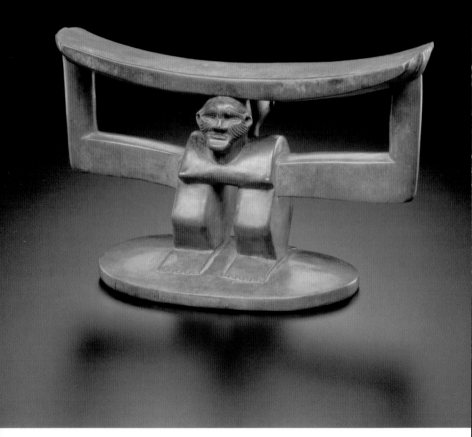

17 Mbala (giguma) headrest

Northern Mbala, Bandundu, Democratic Republic of Congo
Wood (Croton sylvaticus). Height 16 cm, length 24 cm
Anc. coll. H. Pareyn
Musée Royal de l'Afrique Centrale, Tervuren, Belgium

What a strange figure!

The proportions are all wrong; huge long arms – long enough to support a large tray – and a foreshortened trunk with a woman's chest and the legs slightly bent to take the weight of a heavy load. In this photo you can just see a second head and feet. In fact this object has exactly the same figure on either side, only the arms and hands are shared.

It's unusual to carry things on your head!

In Africa it's actually the most common way of carrying a heavy load – with bundles at both ends of a yoke across the shoulders, positioned on the back with a strap across the forehead or simply balanced on the head and held in place with the hands. People all over the world have developed their own ways of carrying heavy objects.

◊◊◊

His face is really scratched and ugly.

It does seem strange that the body is so smooth but the face is streaked. The diagonal lines on the cheeks probably represent scarification meaning that the figure belongs to a particular community. These are the only elements which might allow us to identify the subject of the sculpture.

◊◊◊

The wood is so smooth it makes you want to stroke it

You're not allowed to touch objects displayed in museums for fear that they might get damaged, but it's easy to imagine how pleasant it would be to touch such a smooth and shiny surface. The use this carving has received has added to its smoothness; the corners have become rounded. Many collectors particularly value the smooth shiny patina of African wood carvings like this.

What went on top?

This is what is known as a headrest (or more accurately a neck or cheek rest) and it is used as a pillow in many parts of Sub-Saharan Africa. In order not to ruin their hairstyles by sleeping with their heads on the ground people would sleep with their necks or cheeks resting on one of these. It was possible to maintain a hairstyle in this way for more than two months. It was thought that these headrests were good for ensuring dreams – which in most societies were believed not to be flights of imagination but reality. The ancestors would communicate with the sleeper through their dreams and they would then have a specialist interpret the dreams for them. Some African societies would use the headrest as an aid to divination or as funeral furniture, as an intermediary with the hereafter.

It can't be very comfortable!

You must have to get used to it, although in hot climates it is probably good to have air circulating around the head as it is lifted up. Most headrests in Sub-Saharan Africa are wooden but some are made of bone. Elsewhere they have different names and appear in different materials such as the alabaster *chevet* in Egypt, the ceramic 'pillow' in China, or even made from a human skull in Papua New Guinea.

◊◊◊

Do all Africans sleep with headrests like this?

No. Not all African cultures have headrests. In West Africa they seem to have been rare – apart from with the Tellem people in Mali who placed them in shrines from the eleventh century. In fact, for those societies that did have headrests they were a prestigious item and would generally be reserved for use by a few high-ranking individuals. Among the Mbala people of the Democratic Republic of Congo (where this sculpture comes from), only the heads of families or community leaders would use them. They all featured female caryatids back to back. The chief resting his head on small figures representing his people may be a metaphor for his duty of listening to what his people have to say.

Are all African headrests a similar shape?

No. They come in all sorts of shapes and sizes. Many come from the Democratic Republic of Congo and some are more elaborate than others with different finishes depending on the community of origin – some have several figures, some are more or less abstract. From eastern to southern Africa they tend to be simpler in design. It's interesting to note that the semi-nomadic people of Somalia and Kenya, who are known for having almost no statuary in their cultures, attach a great deal of value to their headrests as they are almost their only furniture. Given their mobile lifestyle, creative expression among those tribes came not only through everyday objects but particularly through music, dance and body art – all of which are highly portable but hard to display in museums!

This could almost be called 'design'

Yes. African art is often described like this. Lots of objects like this one are very architectural in style, making use of size, emptiness and fullness. They have very simple lines and demonstrate attention to the use of light. Here, for example, the arms are particularly well executed – they extend in an organic, subtle upward line from the torso to the elbows whose wrinkles are faintly sketched with a delicate crease. Figurativeness takes a back seat.

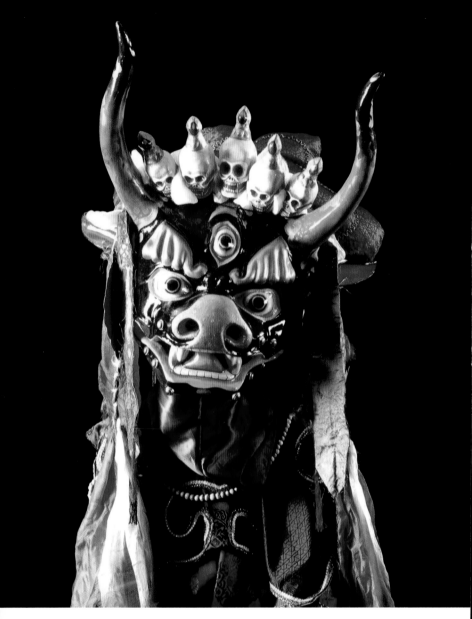

18 Tsam dance mask

Mongolia
Late twentieth century
Papier mâché
Musée international du carnaval et du masque, Binche, Belgium

It's really scary!
Yes, it's deliberately scary. This Mongolian mask looks very demonic thanks to the long horns, the bristly eyebrows, the hypnotic eyes, the snub nose and the flared nostrils. It's either the god of death, *Yama,* or the *Yamantaka,* who vanquishes death. Both are represented by a bull with a blue head (blue inspires fear as it symbolizes both severity and dignity) but it is impossible to tell them apart without the distinguishing objects which the dancer would carry – either a bludgeon in the shape of a skeleton or a bowl made from a human skull. The gods were originally wild demons and when they became protectors of their religion they retained their monstrous appearance. The masks which embody these deities aim to guarantee the success of Buddhism by demystifying obstacles and eliminating enemies.

He's got a crown of skulls!
Religious masks of this kind often include skulls (here each wearing a crown of their own). It is said that they symbolize victory over the five evils as perceived by Buddhism (five being a key number in Buddhism); anger, passion, pride, jealousy and desire. Here the five skulls indicate that the mask is dedicated to a high ranking protector deity (the king of death). Three skulls would indicate a minor protector and one a local deity.

◊◊◊

There's a third eye in the middle of the forehead!
This is a holy attribute symbolizing wisdom. The third eye – in physical form here in the forehead – transcends duality and symbolizes the ability to see to the heart of things.

◊◊◊

What is the mask made of?
Like most masks of this kind, it is made of papier mâché which has been painted and varnished to make it shine. Even old masks of this style can look brand new because they were often re-painted and re-varnished as a mark of respect before each use. In fact this one was made recently – these days modern Mongolian artists continue their ancient ancestral traditions by working for art collectors as well as monasteries.

How did Buddhism become the most widely practiced religion in Mongolia?

Mongolia was home to Genghis Kahn who built the largest empire on earth. The Mongols reached Lhasa (the capital of Tibet) in the eighth century and by the thirteenth century their empire stretched as far west as Europe. Buddhism reached Mongolia in the thirteenth century but it wasn't until the sixteenth century that it became truly established. Zanabazar (1635–1723) was both a *lama* (Buddhist monk) and an artist (he created many sculptures of Buddha and many masks) and is a key figure in Mongolian Buddhism. He was the first in the line of *Bogdo Gegen* (earthly and spiritual leaders of the country) and is considered the founder of classic Mongolian art. Mongolian Buddhism has remained true to Tibetan Buddhism, building its monasteries in the same style for example. As a result the masks used in Mongolian monasteries are stylistically identical to Tibetan ones – as with this particular mask the only way to tell where one is from is to refer to where it was obtained. During the Soviet occupation in the twentieth century the monasteries were destroyed and nearly a hundred thousand monks were sent to the camps in Siberia. But Buddhism never died out and it has had a renaissance since the fall of communism in 1991.

◊◊◊

What dance is this mask used in?

Masks like this are used in the amazing, mimed, religious dances known as *cham* (*tsam* in Mongolian language) which appeared in Mongolia in the early nineteenth century.

The dances take place inside monasteries and their staging – with music and shimmering silk costumes – is particularly breathtaking. These spiritual dances are a form of ritual offering with their origins in tantric Buddhism. The dancer wears the mask on his head (he can see out of the mouth) and performs a set choreography which is based on scenes from a *mandala* (a symbolic representation of the universe used as an aid to meditation).

But it's not acting. Before the dance, the monk will prepare himself, through meditation, to become the deity. As he dances he takes on the deity's power and transforms and purifies his environment. In the past these dances were performed behind closed doors in monasteries, but then some were opened up to lay people who began to come in great numbers and from very far afield to participate.

What roles are there in a *cham* dance?

On the solstices these dances would celebrate the victory of the forces of good over evil, of light over darkness. These dances are Tibetan in origin and Tibetan tantric Buddhism also includes beliefs from the more ancient religion known as *Bon*, (a kind of shamanism based on the struggle against evil spirits). The dances were designed to chase away evil spirits by invoking powerful divinities. Involving a great number of different masks, they were a kind of exorcism and a form of protection. *Yama* (one of the two possible identities of this mask) was the great protector of the religion and guardian of the dead and he takes a central role in the dances. The masked dances also helped believers to distinguish between benevolent and harmful spirits. This is an essential skill as, wandering for forty-nine days after death, their own spirits would have to be able to identify the deities who would help them on their way to a better reincarnation.

◊◊◊

Are there lots of masks in Asia?

Yes, all Asian cultures made and used a huge variety of masks – Chinese dragon masks which protect the community or ensure the prosperity of the new year, masks depicting deadly sickness demons in Sri Lanka and masks revealing spirits searching for the dead in Borneo for example. Asian masks are generally revered because, when they are of deities, they don't simply represent the deity but are believed to be actual substitutes for them by means of the dancer becoming the deity itself. In both Tibet and Mongolia masks are precious objects piously kept in special monastery rooms.

Why do people on all continents use masks?

Ethnographers like Roger Caillois have noted that masks are sometimes even more widespread than tools, such as the plough or the harpoon, which you might assume to be far more essential! People communicate with their faces so nearly all peoples used – and still use – masks to hide the truth from one another. Referring to the frequent religious function of masks Claude Lévi-Strauss said 'Masks bring the gods to earth, show them to be real and let them move among us.'

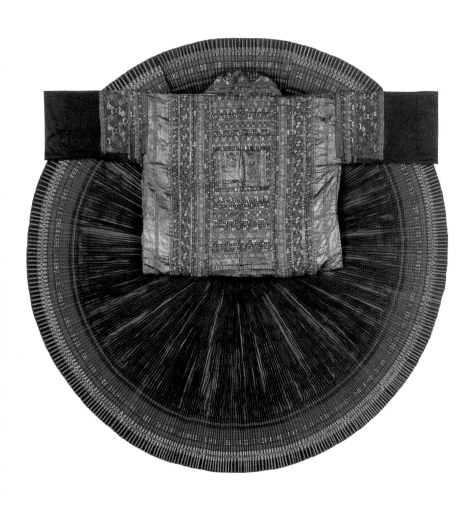

19 Miao women's celebration clothing

South-west China, Eastern Guizhou, Huangping District
c. 1950
Indigo dyed cotton and silk, embroidery, potassium permanganate and gentian flower dye, ribbon. Bodice height 83 cm, width 127 cm including sleeves. Skirt width 72 cm, depth 135 cm
Musée des Arts asiatiques, Nice, France

It looks like the sun!
The skirt of this outfit has been laid out flat like a shining sun. On the bodice you can see how the back is decorated with sumptuous appliqués (pieces of material that have been delicately embroidered then sewn onto the fabric). To complete the look this festival clothing would be worn with an elaborate hairstyle, leggings and silver jewelry. It was worn by the women of the Miao (an ethnic minority from southern China) for whom weaving, embroidery and jewellery were the most important forms of artistic expression. Each magnificent costume would take several years of painstaking work to create.

It's a pleated skirt
These were also sometimes known as 'the skirts with a hundred pleats' but they can have up to five hundred pleats – requiring more than ten metres of fabric! There are several ways of creating the pleats. In one method the fabric is placed around a wooden barrel (or a large basket) and tied in place with rope. Once the pleats are in place they are regularly doused with starch and then dried in the sun. Alternatively, vertical lines are scratched with a nail onto the starched and dried fabric and it is then pleated very tightly on a semicircular piece of bamboo, put into a thick bamboo tube, steamed and dried.

◊◊◊

It's all shiny!
The shine is the result of a specific technique used by a group of Miao in the Huangping region. First the fabric is dyed with indigo then it is repeatedly soaked in concoctions made from different kinds of leaves. It is then beaten on a smooth stone with wooden mallets to give the shiny finish designed to evoke intense sunlight. The golden brown colour visible on the surface of this kind of costume used to be achieved by adding gentian on the beating stone. Gentian was later replaced by potassium permanganate – it's usually used to disinfect water which it turns purple. That explains why anyone that touches these costumes gets purple marks on their fingers!

Are the Miao people very fashionable?

Yes. In fact for them looking after their appearance is a matter of courtesy. Festival costumes like this are worn to mark births, marriages and deaths. Young women of marriageable age wear the most sumptuous costumes – particularly on the festival day on which they are set to meet their future husbands. The richer and more heavily worked the costume the more influential the girl's family.

◊◊◊

So does this outfit tell us about the wearer?

Yes. The Miao have a strong oral tradition and their clothes represent a kind of coded language. Clothing is not only for covering the body but also – according to the different colours and decorations used – to protect the wearer.

The costumes are personalized through the choice of colours, techniques and decorations and they differ according to not only the group of Miao but also by village and even by family. In the past each motif held its own associations evoking, for example, relations with animals, the solidarity of the clan, health, prosperity or protection from childlessness. Some of the designs would be copied from generation to generation and others would be invented as personal touches by each embroiderer. But over time the meanings have often been lost.

◊◊◊

Do the Miao always dress up like this for celebrations?

With changes in their lifestyles and the opening up of China since the 1990s fewer and fewer Miao still wear these traditional costumes – except in regions where they may only have one set of clothes or where they are keen to maintain this tradition. Some of these costumes were brought back by the first Europeans to visit southern China in the nineteenth century (mainly doctors, diplomats and adventurers). Then westerners had to wait until the 1980s to be allowed to return. When they did so, they brought back more of these costumes thus broadening their fame and popularity.

Who made the costumes?

Traditionally the men would be responsible for silver jewelry (symbols of wealth worn by the women) whereas the more important textile arts were the women's domain. But there were no specialists for this kind of work. Every woman would sew and decorate her own costumes for pleasure in the free time she had after her work in the fields and the home had been done. Once the cloth had been woven (or bought at the market) it would be dyed, embroidered with silk thread and then covered in appliqué. As soon as little girls reach their seventh or eighth birthday their mothers start to pass on their skills to them, because it is said that a woman who can neither weave nor embroider will never find a husband! Once they reach adolescence they can show off their skill by preparing a marriage trousseau. Today young girls tend to neglect these ancient traditions in favour of a more modern lifestyle.

How would they wear their hair with this kind of costume?

Like the clothing, the hairstyles follow a complex code. Until they reach fifteen years old the girls in this region wear their hair short. Then they let it grow, but they remove hair from the hairline and wear a tight hat to which a silver crown is added on festival days. Once they are married they cover their hats with a handkerchief and when their first baby is born they stop wearing the hat altogether, covering their hair with dark fabric and a handkerchief instead.

◊◊◊

Are the Miao different from other Chinese people?

The Miao are estimated to number some 6 million in China but they are linguistically and culturally distinct from the Han majority. For a long time the Chinese believed them to be barbarians but they were officially recognized as a minority group in the 1950s. During the course of history they were rejected by the Han and some migrated to neighbouring countries such as Laos, Vietnam and Thailand, where they are known as Hmong or Meo. Others moved to the mountainous regions of south-west China which provided some natural defence, allowing them to observe their own customs and live apart from the Imperial Chinese court. Since the 1990s some Miao have sold their costumes to westerners and as a result a whole tourist folklore has sprung up around them and imitations have started to be made.

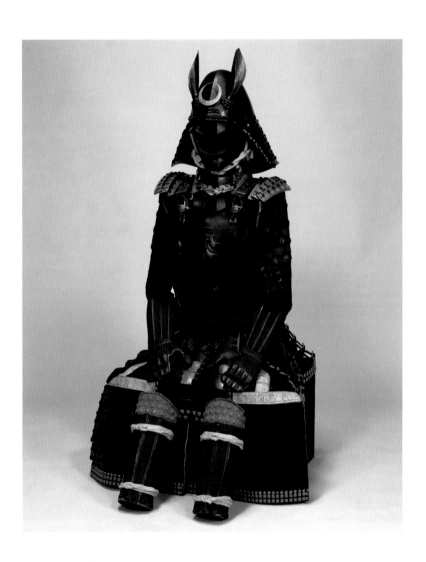

20 Gusoku armour

Sengoku era, attributed to Akechi Samanosuke, Japan
Momoyama period (1573–1603)
Metal, silk, leather. Helmet height 16.7 cm, breastplate height 36 cm
National Museum, Tokyo, Japan.

It looks like Darth Vader with ears!

In the film *Star Wars* the character Darth Vader does wear a helmet that looks like a Japanese one. But this isn't a film costume. This is real armour that was worn by a Japanese samurai around the sixteenth or seventeenth century.

◊◊◊

Do we know who this armour belonged to?

We can't be 100 per cent certain, but this suit of armour is sometimes said to have belonged to Akechi Samanosuke (1536–82). He was a real samurai and is also the hero of the video game *Onimusha 3: Demon Siege*!

What is a samurai?

A samurai was a professional warrior. In Japanese the word samurai means 'in service' and from the twelfth century they were employed by the nobility. The samurai dominated Japanese society for seven centuries undertaking wars to gain control of territory. After the unification of Japan in 1600 they no longer fought but their armour was used in parades or worn during official visits. After the Meiji restoration in 1863, soldiers in the national army stopped using this kind of armour in favour of more western-style uniforms.

Did the samurai have a belief system?

Yes. The samurai fought for a particular family, a region or for money but they had to respect a strict warriors' code (*bushido*) which was a sort of protocol with fixed rules of behaviour: obedience, honesty, valour and respect for the enemy. So the samurai embodied the values of loyalty, strength and courage. They rode horses and though their traditional weapon was the bow and arrow it is the sword that has come to symbolize the way of the samurai.

What is the armour made of?

This armour is known as *gusoku* which means 'complete equipment' and it's composed of a number of elements to protect the body, the limbs and the head. The breastplate is made of embossed metal, decorated with skulls and a Chinese character that means both '10' and 'heaven'. It needed to be strong enough to withstand most blows. The underskirt is made in seven sections so as to allow ease of movement – particularly during combat on foot. Beneath these sections removable leggings made in two sections protected the thighs and the shins would

be protected with separate metal covers. The plates of shoulder armour were also separate pieces that could be hooked on like epaulettes. The sleeves were made of chainmail and smaller plates to protect the arms. Finally a moulded piece of metal covered each hand.

The helmet looks very sophisticated
This one has articulated protection for the back of the neck. These embossed metal helmets became real works of art from the seventeenth century. The ornamentation on the front would be personalized for the wearer with motifs such as antlers, insects, family coats of arms or, like here, a moon between two horse's ears! These extravagant decorations – visible from afar – would allow the troops to make out their samurai leaders, even from far behind them on the battlefield.

The helmet was fastened on with a mask, a semi-mask or a simple chinstrap (which would also protect the face to a greater or lesser extent). The strap here is made of iron. It follows the line of the chin and the cheeks and hides the bottom half of the face. There is also a gorgerin (the lower part of the helmet which – as you can see – covers the throat and neck) to reduce the risk of decapitation. In full armour the samurai was transformed into a terrifying, almost supernatural being with a metalic face and fierce grimace, threatening teeth and bristling moustache.

◊◊◊

Is other Japanese armour more or less the same?
No. As war and weaponry evolved so to did Japanese armour. The oldest metal suits of armour date back to the ninth century. They are heavily influenced by Chinese design which is characterized by the use of leather strips. That kind of armour was developed by the Mongols and other nomadic riders from the steppes.

Is this breastplate typically Japanese?
Strictly speaking Japanese armour was made in the same way as the skirt here – composed of rectangular strips. Notwithstanding the iron sheet (inspired by European breastplates), this suit of armour was definitely made in Japan. It's the result of cultural cross-fertilization; when cultures come into contact with one another they inspire one another, borrowing techniques and shapes which then become part of local practice. When the Portuguese introduced firearms in 1542 the Japanese had to protect themselves more effectively. Their armour – made

using the strip design – had been quite efficient at deflecting arrows and swords but was no longer enough to protect the samurai against guns. For the same reasons helmets began to be made of metal. Despite the huge developments in the art of war it was still the bow and the sword that remained the emblematic weaponry of the samurai – guns were never considered prestigious.

◊◊◊

Was this kind of armour practical?

It was very flexible thanks to the design – which you can see here in the skirt and the helmet. Small lacquered iron plates (some were covered in silver or gold) were linked together using colourful silken cord. Japanese armour was designed not only to protect but also to strike fear into the enemy. Though you see it in a glass case at a museum, it looks beautiful!

The leather strips were as strong as chainmail but much more flexible. The very specifically tailored flaring on the back of the neck allowed the warrior to move his head from side to side as well as up and down. The underskirt is also rendered very practical and flexible by the strip-sections attached to one another with laces. Japanese armour was much lighter than western steel armour, which could weigh dozens of kilograms and was so heavy that warriors had to be hoisted onto their horses using a block and tackle.

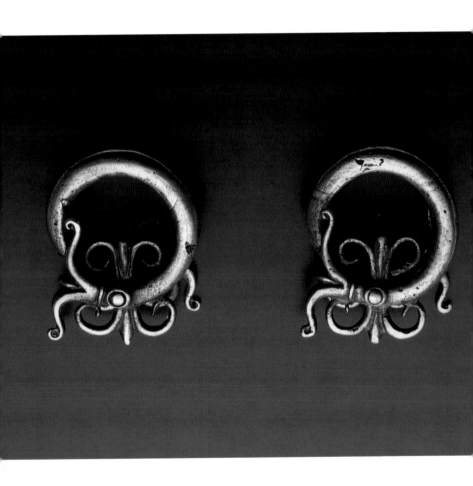

21 Dayak earrings

States of Kalimantan or Sarawak, Borneo
Twentieth century
Brass. Height 5.3 cm
Anc. coll. Musée Barbier-Mueller
Musée du Quai Branly, Paris, France

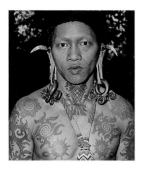

They look like massive earrings

That is exactly what they are! But they aren't for women. On the island of Borneo these particular earrings were worn by men.

They are over five centimetres long and very heavy. In fact they were so heavy that they would permanently deform the earlobes, sometimes stretching them so far that they reached down to the shoulders – as in this photo.

Earrings for men?

In some societies earrings are worn by men, in others by women and in others still by both men and women. For the Dayak (not a single tribe, but a group of northern Borneo tribes that never converted to Islam) it is customary for both women and men to wear very heavy earrings.

These earrings had special qualities – the ones warriors wore, for example, offered not only spiritual but also physical protection in battle. They were reserved for high status individuals and bear the *aso* motif – a mythical animal that acted like a kind of weapon to protect the wearer from spiritual attack.

Where is *aso*?

The *aso* is always shown in profile and here is hidden behind the curves and spirals of the design. You can make him out when you find his round eye at the bottom of each ring, surrounded by pairs of symmetrical curls. To the left you can see his mouth opening into tendrils that finish in his traditional spirals and there is a pointy tongue between the jaws. Then you see that the rest of the ring is his body curled around like a snail shell. At the other end is another animal head.

What sort of animal is it?

The *aso* is a powerful, protective animal spirit and a motif that is frequently used in the islands of South East Asia (a region including Indonesia, Malaysia and the Philippines) where these earrings come from. Though the term *aso* literally means 'dog', it is used to refer to a creature that is half dragon, half snake. Perhaps this is a roundabout way of talking about a dragon without having to say the word? In Borneo the Dayak use the *aso* motif on jewellery, houses, carvings, embroidery and clothing. You can also see it in the middle of the tattoos on this man's chest.

The deformed earlobes are really ugly!

Just because it isn't what our cultures consider to be beautiful doesn't mean that it is truly ugly. The idea of what makes something beautiful is different all over the world, but everywhere you go human beings try to transform and beautify their bodies. There are all sorts of permanent or temporary means of achieving this, from hair-removal and make-up to tattooing, tooth filing or lip and ear-piercing. We might be shocked by their stretched earlobes, but the Dayak would probably be just as shocked to learn that some westerners go in for bodybuilding, dye their hair, get fake tans or even undergo operations to change their noses, increase the size of their breasts or remove wrinkles or cellulite.

So the Dayak actually think it looks nice?

Yes. It fits with their idea of beauty.

Voluntarily transforming your body is like displaying a kind of code, showing that you belong to a certain group, in which you occupy a certain position, and that you accept certain traditions. The custom is so ingrained that following it is probably not even questioned.

In the West, changing the way your body looks – with surgery or piercings – is more of a personal choice. It's about achieving the ideal of beauty that your society espouses. Or it can also be about rejecting that ideal, the desire to stand out and look different.

Is jewellery important in the islands of South East Asia?

Yes. The people of this region have a long tradition of creating jewellery, much of which is superb. Jewellery can be a religious or social symbol, displaying the owner's wealth or confirming an important event like a marriage. Considered as hereditary treasure, the jewellery is passed down through a family or exchanged on the occasion of a marriage. Nobles would have golden jewellery whereas the common people had jewellery made of bone or shell. Brass was highly prized by the Dayak and only used for their earrings, which were almost always brass.

Well, if it decorates the body then it makes sense

The Dayak are famous for their love of body ornamentation. To mark their coming of age, tradition demanded that they had tattoos all over their bodies and wore clothing of rich fabrics, and jewellery including bracelets, arm-rings and anklets and even ornaments in their hair, on their necks and in their ears.

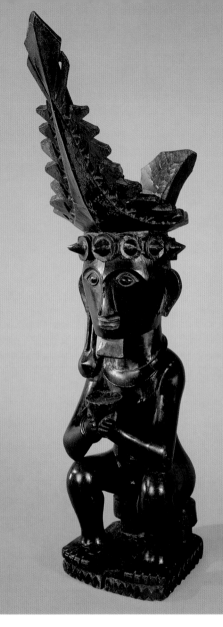

22 Nias ancestor figurine (adu siraha salawa)

Northern Nias Island, Indonesia
Wood. Height 79 cm
Acquired by A.N.J. Th. van der Hoop, 1971
Volenkundig Museum Nusantara, Delft, Netherlands

Let's describe this wooden carving

It's a man (he's clearly got a penis). He is staring into the distance and sitting very upright on a stool. He has a pot in his hands and is wearing some striking jewellery, including a large earring in his right ear and an enormous headdress almost as large as he is. A single line on the upper lip suggests a moustache and a rectangle below the chin represents a stylized beard. As a whole it is very characteristic of the human statues made on the island of Nias to the west of Sumatra in Indonesia.

The arms make a W

Children who are learning to read will enjoy noticing that his arms make a W shape. This W is actually a very specific part of the formal Nias style.

◊◊◊

What does all his jewellery mean?

The jewellery reveals how important this man was – as do the care with which this sculpture was clearly made and the highly polished finish it has been given. The adornments are similar to those worn by Nias nobles. Their headdress would be made of ferns attached to a band decorated with gems and would symbolize the cosmic tree, the tree of life.

According to Nias mythology the chief was originally one with this tree. The jewel in the right earlobe is a masculine symbol. In Nias only women wear earrings in both ears. The man is also wearing a necklace (the real one would be made of gold) and a bracelet (which would be stone or metal).

◊◊◊

It must be a pain to wear such a great big crown!

No doubt! Of course the important thing was what the crown represented, so it's interesting to note that ornamentations of this type were often heavy, cumbersome, fragile and uncomfortable!

What does gold represent in Nias?

Gold was a symbol of godliness and so was reserved for the aristocracy – even the goldsmiths were themselves members of the nobility. Owning and wearing gold at festival times demonstrated one's wealth and social importance, particularly as this gold came from the neighbouring island, Sumatra – there isn't any in Nias! It's hard for us to believe, but in Nias a man's wealth was not measured by how many goods he had accumulated but rather by his ability to produce goods to give away. Golden jewellery was considered both a family possession and also a ceremonial means of exchange – for example a wedding gift. Some items could serve as mediators between earth and the supernatural, others were charms offering protection from bad spirits.

It's an ancestor figure – what does that mean?

An ancestor figure represents a person who has died. Knowing what happens to us after death is a great human preoccupation. Many peoples believe that we go on living in another form and societies that practice ancestor worship believe that the dead can be transformed by a ritual into ancestors who, in their new form, will maintain relations with the living. In Nias those relations were established through the intermediary of the ancestor figures, these treasured carvings.

Which ancestor is it?

It's one of the ancient original ancestors, a chief who died long ago. This kind of statue is called *adu siraha salawa* which is usually translated as 'ancestral spirit'. *Adu* is the general word for carving. Within the *adu* reside the spirits of ancestors, gods and illnesses. *Siraha* signifies protection and *salawa* corresponds to the title of the chief in the north of Nias. These carvings are distinct from the more modest *adu zatua* figures which are also ancestor figures but represent those who have died more recently.

What were ancestor carvings for?

The carvings supported prayers. With the intermediary of an offering these carvings would allow you to request blessings, protection, prosperity or even healing from the ancestors. The ancestors were figures of authority, benevolent or not, depending on the relationship you had established with them.

Placed so they could be seen from the outside, this type of carving would specifically protect the chief's house. If the chief fell ill or was making a significant undertaking – like war – then offerings would be made to the ancestor. These beliefs disappeared from the island following the mass conversions to Protestantism at the beginning of the twentieth century.

How do you become an ancestor?

The transformation into an ancestor would take place in two phases, as in many societies which venerate their ancestors. Generally, care would be taken to capture the dying person's last breath in a bamboo tube and then at the funeral a tree would be planted close to the body. The ritual transformation of the dead person's spirit into an ancestor would happen at a second funeral service when the ancestor figure would take on its new role, with the carefully preserved breath being breathed back into him.

Some experts have reported a different version: the transmission of the soul to the carving would happen with the recapture of a spider (representing the soul) that had previously been placed into the dead person's tree. The spider would then be placed into the carving.

◊◊◊

Are there figurative carvings everywhere in the islands of South East Asia?

The islands of South East Asia reach from Oceania to Madagascar, forming a cultural cross-roads between continental South East Asia and Oceania. The languages of the region belong to the family known as Austronesian. Many of the peoples who did not convert to any of the imported religions (Hinduism, Buddhism, Islam or Christianity) or who converted late have maintained their own traditional social and religious structures and still practice ancestor worship. They have made many carvings (in stone or wood) but these carvings remain less well known than African or Oceanian ones.

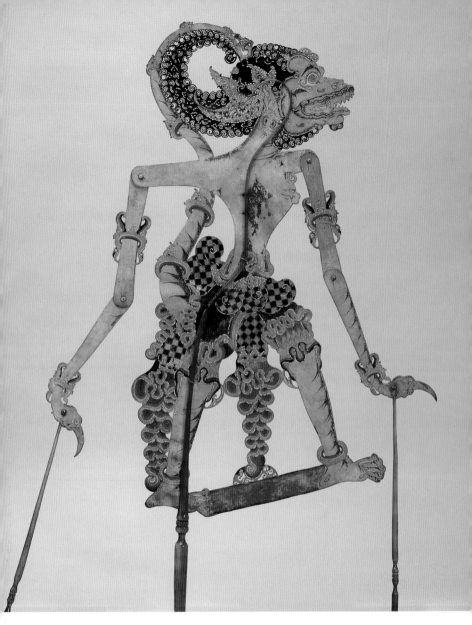

23 Javanese puppet of Hanuman

Wayang Kulit, Java, Indonesia
Before 1890
Leather and buffalo horn. Height 75 cm
Staaliches Museum für Völkerkunde, Munich, Germany

He's got sticks coming out of him!

It's a flat puppet. Cut out of buffalo hide, it's virtually two-dimensional but it is intricately painted on both sides. It's the eye which really brings the character to life and it would have been cut out last. There is a stem of buffalo horn attached along the length of the figure and, to make the puppet stand upright, the puppeteer would place this into a banana tree trunk. The arms (which are jointed at the shoulder, elbow and wrist) are moved using the little horn sticks attached to the hands.

Why has the puppet got so much cut-out detail?

Because with this kind of puppet, it's the shadow that is important. In fact, the puppeteer works behind a backlit screen so that from the other side the audience can see the detailed silhouette of the puppet moving as if by magic. No less than twenty pairs of scissors and awls are needed to achieve this level of detailed cutting out.

Traditionally the figure's body is shown face on and the face and limbs are shown in profile (although you can still see that this figure has five toes). The cut out sections let the light through and create decorative effects whilst also showing the detail of a hairstyle here or an expression there. On the Indonesian island of Java, men, women and children all watch the puppet shows, choosing which side of the screen to sit on, depending on whether they want to see the puppets themselves or the shadows.

◊◊◊

What's this kind of entertainment called?

In the West we sometimes refer to the projection of silhouettes onto a screen as Chinese shadow theatre. In Java, where this tradition stretches back to the eleventh century, it is known simply as theatre (*wayang*). This kind of art still flourishes in Asia and you can see shadow theatre with puppets or actors in China, India and Thailand but also in the Near and Middle East. In Indonesia there are various forms based on the use of puppets; shadow puppetry with leather puppets like this one, shadow puppetry with flat wooden puppets, and three-dimensional puppetry. The last two forms both involve masked actors.

It's like Punch and Judy – made to make children laugh

Yes it is. But that's not all. Shadow puppetry is designed as entertainment but it is for adults as much as for children and it also has a sacred, moral and educative purpose. The cast of characters includes heroes and anti-heroes who demonstrate how to behave and how not to behave. At important family occasions such as weddings, births or funerals some *wayang* productions (which generally start when the sun goes down) can last as long as eight hours! These days the most famous puppeteers and their troops tour internationally.

What stories do they tell?

They tell the stories of ancient Indian epics (like the *Mahabarata*) or local myths which end with the triumph of good over evil and the return of peace. This puppet is a character from the *Ramayana,* a sacred epic poem written in India between the second century BC and the second century AD and popularized throughout South East Asia with the spread of Hinduism. The *Ramayana* was translated into Javanese in the tenth century and has evolved as part of Java's oral tradition.

This is a very popular tale which relates the adventures of Crown Prince Rama's search for his wife, Sinta (Sita in India), who has been kidnapped by the demon Ravana. Helped by an army of monkeys – led by Hanuman – Rama manages to find his lost bride.

So this puppet is meant to be a monkey?

According to the *Ramayana* Hanuman is the monkey general. In Javanese tradition he is thought to be one of the sons of Bathara Bayu, the wind god, and is characterized by his courage, honesty and nobleness.

He is recognizable by the two claws that give him supernatural strength and allow him to kill his enemies. The long tail, here reaching up the length of his back to the top of his head, reminds us of an element of the tale: having been taken prisoner while attempting to rescue Princess Sinta he escapes by flying (since he is the son of the wind) but as his tail is on fire he accidentally sets the whole town alight!

Are the different characters easy to recognize?

No they are not – especially as there are almost two hundred of them in Javanese folklore. Luckily the Javanese are so steeped in their traditions that they do recognize them. Some are specific characters (Hanuman, Rama, Sinta) but others are just archetypes such as servants, hermits, giants and so on. Their appearance follows a very particular code; a red face, for example, corresponds to a very

emotional character, a white face represents a refined character, a black face is a mixture of all the colours, or all the positive attributes, so it represents inner strength and wisdom.

◊◊◊

So the puppeteer isn't just an entertainer?
No. The role of the *dalang* (which translates as 'one who recites' in Indonesian) goes well beyond simple fun. They are real artists, experts in mythology and well respected spiritual guides. To make the puppets come to life they have to be truly multi-talented. First there are the tales and myths to learn and to recount or sing (they may add their own digressions or funny asides). Second they give every character a distinct voice which has to remain consistent throughout the whole show. And third, handling all the puppets at arms' length for several hours – while sitting cross-legged – demands real physical stamina!
Following a long apprenticeship they will practice their art travelling from village to village with a band of musicians and a few singers. There are between two and three hundred professional *dalang* in Java today, some of whom are extremely famous.

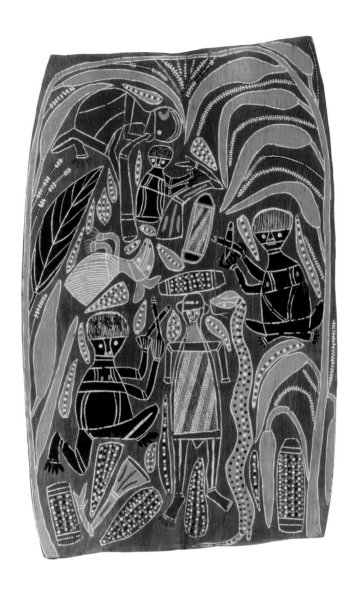

24 Aboriginal painting

Funeral ceremony: the feast. David Malangi (1927–99)
Milingimbi Community, Central Arnhem, Australia
Painting on eucalyptus bark, natural pigments. Height 48 cm, length 41 cm
Collected by Karel Kupka 1963
Musée du Quai Branly, Paris, France

What story does this picture tell?

This picture retells an Aboriginal myth about four men from the same territory. One of them is bitten by a snake and dies. The others carry his body to two trees (like any element of the natural environment, a sign of the presence of the ancestors) where they spend the day watching over his body. One of them goes into the bush to find food and brings back a kangaroo and some fruit. The painting depicts the meal that they eat between two important phases of the funeral rites. Two figures painted in black (to the right and left of the body) are knocking tapping sticks together. A third (top left) plays the didgeridoo (he is harder to see as he is the same brown colour as the background).

What is the didgeridoo?

It is an Aboriginal instrument. Made from a termite-hollowed eucalyptus trunk, it is used to communicate over long distances and to accompany the songs of the funeral ceremony.

The man in the middle is all stripey!

He is Gurmirringu, the great hunter and ancestral forefather. It was following his death that the first funeral rites were organized. The painting shows him laid out and ready for burial. The seated men are taking part in the funeral ceremony. They are shown as black because their bodies haven't been painted. The stripey design on Gurmirringu's body shows how important he was. The colours here are the colours of his clan and they resemble the kind of body painting that is used during certain rituals – in Oceania the body is often adorned with painting, piercings, tattoos or scarification.

Where is the kangaroo hiding?

He's going to be eaten so he's already been cut up. His head, body and forelegs are above the black character on the left. The back legs are scattered amongst the other elements of the story.

◊◊◊

Why are the elements of the story all jumbled up?

The elements of the story are painted floating in no apparent order. This may have been done to evoke the different interpretations that are possible with any Aboriginal painting, depending on the viewer's (and the artist's) degree of

initiation. Generally, bark paintings present the public (non-secret) version of a story but the painter may hold something back, not telling the whole story – perhaps to protect the religious nature of the tale. In this way he can depict the myth without it being revealed in its entirety.

◊◊◊

It looks like a child's painting!
This kind of comment is often made about non-naturalistic paintings. It's a particularly western view where a painting's success is marked by the degree to which it mirrors reality. But Aboriginal art doesn't aim to be realistic in that way. Both the story and its meaning are important but they are evoked without being completely described. The artist puts a lot of thought into how best to lay out the story in the available space and the composition of the painting as a whole.

◊◊◊

Why aren't the edges straight?
The edges aren't straight because the artist has kept to the natural shape of the piece of eucalyptus bark on which he painted. (Although eucalyptus bark is a traditional surface for Aboriginal painting, nowadays artists also use canvases.) Once it is removed from the tree the bark is flattened and polished until it is smooth, then coated with a single colour (often red) as a background. The artist then paints their picture using natural pigments – white from kaolin, black from charcoal, red and yellow ochres from the soil.

Was this painting made as a decoration?
No. Aboriginal art is above all about spirituality and identity. Even modern paintings made for non-Aboriginal audiences usually have a religious meaning. Aboriginal religion is based on the concept of 'the dreamtime'. During the time of the ancestors, mythical beings created humans, animals and plants. They appeared to the first humans in dreams and told them the story of the creation of the world and the relationships between man and nature. These stories revive the power of the mythical ancestors and, as they are associated with places and families, they are passed down from generation to generation. They are also often painted on the body, on the earth, on rocks and bark. The story painted here belongs to the artist's father's family group.

Is the painter famous?

Aboriginal painters have an important role to play as they act as trustees of so much traditional expertise. David Malangi is one of the best known bark painters from his region, the Arnhem territory of Northern Australia. He exhibited his work all over the world. He died in 1999.

◊◊◊

Is this painting famous in Australia?

Yes. It appeared on the Australian one dollar note in 1966 without David Malangi even being consulted! It was a period when Aborigines were fighting for the right to full Australian citizenship (which they won in 1967) and Aboriginal art was starting to be admired. In the end the Bank of Australia did acknowledge that Malangi was the painter.

◊◊◊

Why are the inhabitants of Australia known as Aborigines?

Etymologically *ab-origenes* means 'originally from' or 'people whose ancestors were among the original forefathers'. 'Aborigines' is generally used to refer to the first inhabitants of Australia and their descendants. When the British arrived in the eighteenth century they took advantage of the Aborigines being nomadic and declared that they did not therefore live on (or own) the land, which the colonists claimed was empty land belonging to no-one. Though they had lived on the land for around sixty thousand years and numbered over a million, the Aborigines were deported and forced to live on reservations.

Is Aboriginal art very ancient?

Yes. Some paintings and rock carvings have been dated to at least thirty thousand years old. Others still have been dated back fifty thousand years – older than the Lascaux cave paintings in France. Some of the motifs (like the snake or the kangaroo) have been in use for thousands of years and are part of a fascinating artistic tradition. Today, Aboriginal art rivals any other global artistic tradition for vibrancy and inventiveness.

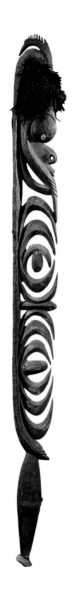

25 Yimam (yipwon) statue

Upper Korewori, Chimbut Village, East Sepik, Papua New Guinea
Wood, cassowary feathers, shells, traces of pigment
Height 266 cm, length 20.5 cm, depth 7 cm
Coll. Alfred Bühler exhibition 1959
Museum der Kulturen, Basle, Switzerland

Is it a skeleton?

It certainly looks like two sets of ribs welded to a long vertebral column. The ribs are hook-shaped – some curving up and others down. The top set curves protectively around the heart (represented by a rounded shape hanging from one of the ribs). In the centre of the lower set of ribs a second, mysterious organ is protected.

This kind of figure, made by the Yimam people of Papua New Guinea, is unique in showing both the external contours of the body and its internal lines. They are known as *yipwon* but they have also been dubbed 'hook figures' due to the curved ribs.

Its only seven centimetres thick, but over two and a half meters tall!

Such a slender sculpture wasn't made to be seen from the front. You only see its depth by looking at the side view. By creating a gap around each solid rib the artist creates balance and makes the character seem finely drawn.

◊◊◊

It's so beautifully carved you've got to admire it!

Many items in western museums are made to be admired, but that's not the case with Yimam art. For them carvings are created with a particular objective in mind, be it contacting the spirits, gaining spiritual power or having a successful hunt. Of course the objective is more likely to be achieved with a beautiful object than with a less beautiful one, so their efforts to create beautiful art were not so much motivated by the search for admiration as ensuring the effective transmission of a message.

◊◊◊

What a funny face!

When you look closely at the face you see feathers, a curved forehead, a very striking eye (made with a shell and outlined in red), a large nose with a pierced septum and a long beard (which may also be a cassowary beak).

Nasal piercing like this is often customary in Oceania and particularly in Papua New Guinea where the nose is considered very seductive. Cassowary feathers like the ones used here for the hair are also used in warrior headdresses. (The cassowary is a large flightless bird with long fine feathers. It can grow to up to one and a half meters in height.)

How does this sculpture stand up?

It can't stand up on its one leg so it would be leant against the back wall of the ceremonial 'men's house' (a building that could be entered only by men) and it would remain unseen by the uninitiated (women and children). The local myths include characters with only one leg and as neighbouring tribes did not speak the Yimam language they named the carvings 'wanleg kaving' in pidgin (from the English 'one leg carving'). Pidgin is a hybrid language that mixes local words with English and in Papua New Guinea it is known as 'tok pisin' (pidgin talk).

What does this carving represent?

This represents a war or a hunting spirit and is designed to ensure success. The carvings' role was to intensify the link between the spirit's power and the huntsman or the warrior, so they were no doubt consulted or used in rituals before hunting or head-hunting trips.

Most Oceanian carvings of human beings are seen as receptacles for spirits, supernatural beings or ancestors. Each carving would belong to a particular group of men and was seen by the Yimam as both a wooden object and also a being in its own right. In this way the statue would allow for a link between the dead, the living, animals and the elements. That said, the carvings themselves were not believed to hold any power at all outside of the rituals through which the spirits were thought to manifest themselves.

◊◊◊

What is 'head-hunting'?

This was the name given to a kind of attack which used to be common in large parts of Oceania and South East Asia. It doesn't happen anymore but it used to involve cutting off the enemy's heads so as to preserve their skulls.

Capturing an enemy head would weaken your enemy's group whilst adding power to your own clan and prestige to you and to your family. For Oceanians, death was not a natural occurrence but came about only as the result of fighting or witchcraft. The Melanesians would avenge death by organizing a reprisal attack or by casting spells of their own. Alternatively if they accepted they had caused a death they might pay monetary reparations (originally in seashells, later in banknotes). Westerners were very disturbed by these customs and to play down their cultural significance, they summed them up with the intriguing and terrifying epithet 'head-hunting'.

What role does the men's house play?

Often the largest, most imposing and most decorated building in the village, the men's house represents the centre of power and activity in many Oceanian societies. It is an institution in itself and symbolizes the group's identity. The men gather there to eat, to discuss community problems and also to work and relax. The men's house can also host funeral ceremonies, male initiation ceremonies and preparations for hunting or war.

◊◊◊

Are the Yimam Papuan?

Yes. Papuan is the term used to refer to the inhabitants of Papua New Guinea. When they arrived, the Portuguese used the term, which means 'curly' or 'frizzy', because of their hair.

Papua New Guinea consists of the eastern half of the island of New Guinea (one of the largest islands in the world) and the Bismarck Archipelago. The terrain is vary varied (including several mountains over four thousand metres) and the islands are multilingual (with over eight hundred languages spoken there). As a country it has a huge variety of cultures and styles of artistic expression.

To be precise, the Yimam live in the northern region known as Upper Korewori (the Korewori is a tributary of the Sepik River). Unusually, we know the exact provenance of this piece and can pinpoint on a map the village of Chimbut where it came from.

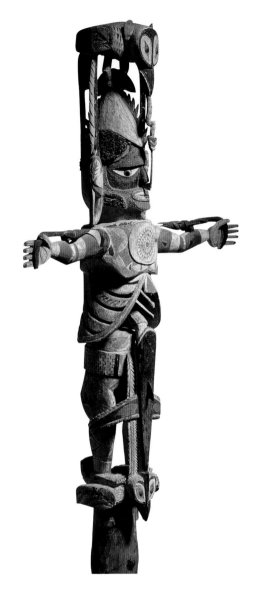

26 Ceremonial malagan statue from New Ireland

Bismarck Archipelago, Papua New Guinea
Wood, pigments, shell. Height 162.5 cm
The Cabinet of Curiosities of the Grand Duke of Baden (nineteenth century)
Anc. coll. Museum of Manheim and A. Speyer
Musee Barbier-Mueller, Geneva, Switzerland

What a lot of things in one sculpture!

Absolutely! It's not easy to take in all the details – but that's OK because the role of this sculpture is to convey multiple and hidden meanings. There is a man standing on an owl with his arms stretched out in the shape of a cross. He's got another owl, which is eating a snake, on his head. The man is holding a bird by the tail which is stretched out along his arms. The fish that is covering the man's legs is actually eating his liver! The designs painted onto this wooden sculpture no doubt contain an abundance of further meanings that we would need the painter to explain.

Despite all the detail it's the eyes that really stand out

The people from New Ireland made their sculptures' eyes using the lid of a gastropod mollusc called a turbo. The shell looks just like a real eye and makes it seem that the statue is really watching us. The face was painted with vegetable resin to make it look lifelike and the ears are pierced just like those of modern day New Irelanders.

The outstretched arms are so wide, this must have been carved from an enormous tree!

No, the arms were carved separately and then attached to the body. New Ireland was the only place in Oceania to use this method to attach arms (and sometimes also ears). Sculptures from other parts of Ocecania are carved from a single piece of wood. The artists would deliberately select soft wood as although it is easily perishable, it is easier to attach elements to it.

◊◊◊

What tools did the inhabitants of New Ireland use to make their sculptures?

In the past, they used tools made from shell, sharks' teeth or obsidian (a very sharp volcanic glass). Metal tools brought by Europeans meant they could achieve greater hollowing effects and also attach more complex elements.

What is the a decoration on the chest?

It's a *kapkap*; a circular ornament worn by chiefs and warriors as a pendant. *Kapkaps* were magnificent symbols of wealth and authority; they were carved from giant clam shells to which cutwork motifs of tortoise shell were added.

What is that under his chest?

This man's ribs are visible to illustrate that all flesh decays after death. This symbolizes that the living must eventually let the dead go. The animals in the statue represent totemic relationships (that is to say the most significant of all relationships).

This kind of statue doesn't aim to be a portrait of the dead person, but rather to portray his vital energy. The iconography used has so many rules that each combination of different designs ought to entail its own copyright!

People who wanted a certain set format – which would have a name of its own – would have to pay in cash (in the past that would have been in shells).

What were these carvings made for?

They were made some time after an important person's funeral; representing a belief in the dead person's brief return to the living before the end of the mourning period. Both the sculptures and the funerary rites where they were displayed were known as *malagan*.

In the societies of New Ireland, all power resided with clan chiefs and it is they who would decide on funeral rites. These rites would be at the centre of the people's social and religious lives and became huge popular festivals which could last weeks or even years. During the ceremonies several hundred sculptures could be displayed in a specially built area. These days this type of traditional sculpture is once again being made, still within the context of funerary rites.

What happened to the sculptures after the *malagan* rituals?

When the ceremonies were over the sculptures would be destroyed to signify the final departure of the dead person's spirit and the final breaking of ties with the living. What we would call the 'spirits' or 'souls' of the deceased were not allowed to remain in the village for fear that they might bring illness or accidents to the living. The rituals were also a chance to pass on to the next generation the right and the expertise to make the *malagan* carvings. So these funerary periods also became associated with initiation periods for boys and girls – the symbolic replacement of one generation with the next. The festivals also brought together neighbouring villages and were a chance to settle legal disputes and strengthen economic ties. The celebrations which accompanied them were ideal for the exchange of goods (ranging from money in the form of shells to pigs, houses and land). In these funeral rites death becomes a source of new life for all of the community.

If the *malagans* were destroyed at the end of the ceremonies then the ones in the museums must be fakes!

Before their wholesale destruction many *malagans* were brought back by explorers. In fact as far as the inhabitants of New Ireland were concerned the important thing was simply that the object should disappear. It didn't matter to them whether it was burned or carried away on a ship – the key thing was that the dead person's influence should be removed from the island. Whilst the explorers described the *malagans* as 'simple pieces of carved, painted wood', for the islanders they represented a significant spiritual and financial investment.

◊◊◊

Why did the Surrealists like this kind of sculpture?

Many Surrealists, including the founder of the movement, André Breton, collected these sculptures, probably because of they are so dreamlike and expressive.

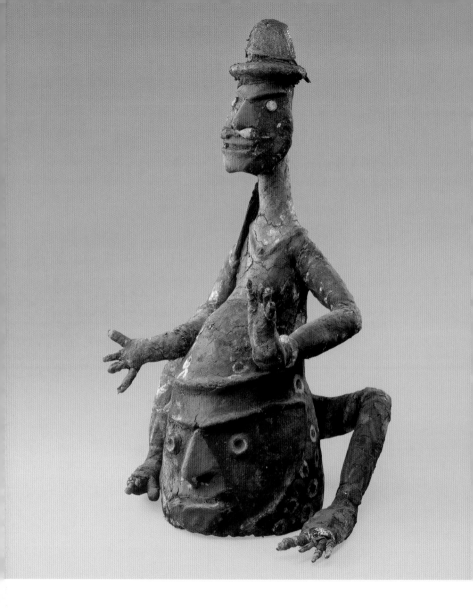

27 Mask-headdress from Malakula

Nevimbumbao and his son Sasndaliep
Vanuatu
Tree fern, plant fibres, paste and pigments. Height 75 cm, length 45 cm
1931 Colonial Exhibition, New Caledonia Pavilion
Anc. coll. Austin, Musée du Quai Branly, Paris, France

It's really ugly!
Well it's certainly striking. Children are often fascinated by this piece but won't hesitate to say how 'disgusting' it is. Maybe that's what the sculptors from Malakula (Vanuatu Archipelago) hoped for. Like all their objects this sculpture wasn't made to be admired but for use in spiritual ceremonies. One of its aims is to unsettle the observer and encourage him to worship. Lots of art from Vanuatu has a similar visual impact and is a strong argument for the power that the beings represented held over the sculptures and their users.

He's playing a drum on another person's head!
He's not actually drumming, but he is holding the head tightly between his knees as if it were a drum and the artist has caught the movement of the hands and feet as though they were beating out a rhythm. The beauty of Malakula art lies in its ability to capture both life and brutality through expressive sculptural forms like this one.

It doesn't look as though it's made of wood
In Vanuatu tree ferns – which are rare elsewhere – are frequently used in place of wood. In tropical climates the trunk takes on a spongy consistency. It's made of layer upon layer of tangled plant fibres. The surface is too rough to paint on so, using a technique known as *surmodelage,* it is first coated with a plant render whose recipe varies (it can include leaves, spider's webs, fibres, coconut milk, breadfruit tree sap and shredded vines) before being painted with brightly coloured designs. As you can tell from the unpainted fingers, the limbs are made of banana leaves. Oceanian cultures use a multitude of natural materials in their art; shells, stones, tortoise shells, feathers, dogfish whiskers, pig's teeth, human hair, animal and human bones, lichen, beaten bark (known as *tapa)*, spider's webs and so on.

They used cobwebs!
Yes, but not just any old cobwebs. They were particularly large and strong ones that only members of a secret society were allowed to collect in the bush. They called it 'ancestors' cloth'. It can still be seen on many sculptures from the region but here it is hidden by the hat and also, we think, under the ponytail hanging on the man's shoulder.

Who are these two people?

These two are the main characters in one of the island of Malakula's myths and are often shown on ceremonial headdresses, many of which are now in museums. The large head belongs to the ogress Nevimbumbao and above her the character with the hat is often thought to be her son, Sasndeliep, whom she is carrying on her shoulders. It's easier to understand this piece when you realize it is a headdress-mask that would be placed on a dancer's head. The dancer would then look like the ogress moving about with her son sitting on her shoulders.

What is the myth of Nevimbumbao?

Nevimbumbao the ogress lived on an island and would devour anyone who crossed her path. One day she managed to capture five brothers who lived on a neighbouring island. The eldest brother was the cunning Ambat – a civilizing hero who revealed to humankind the secrets of the origin of life and also invented funeral rites, sacred pottery and so on. Ambat saved the brothers by having them follow a long banyan root under the sea to their island, but they wanted to get rid of the ogress once and for all and so, taking her prisoner, they forced her to create a new island by transporting sand in a giant clam shell.

◊◊◊

When is this mask used?

This mask-headdress would probably have been brought out for ceremonial dances organized by secret male societies. It appears that this one has lost the two pigs which would have guarded the corners of the ogress's mouth. Masks of mythical people such as Nevimbumbao belonged to the most senior society members. Throughout their lives men would progress through grades or stages which determined their place within society and allowed them increasing seniority in matters of politics and spirituality. Each step would be taken during a major festival at which precious offerings such as curved pigs' teeth (a powerful symbol of wealth) would be made. Pigs were very highly prized and only ever eaten on the occasion of large ceremonies. This progression through life was known as 'the way of peace' and was seen as a way of drawing closer to the spirits of the ancestors (the only real holders of power), serving as a kind of preparation for living a better life in the hereafter.

How do the people of Vanuatu feel about the 'white man' having their sacred objects?
Even though their sacred objects weren't made to last they are not fundamentally opposed to such ancient and rare objects being preserved. But some do wonder why the white man wants to keep hold of ritual objects which ought to be spiritually 'nourished'. Others ask ethnographers whether women are allowed to view the objects which are usually reserved for initiates of the secret societies (which do not include women).

It looks like a Picasso!
Yes, this piece might well remind you of Picasso's work. In fact he owned a sculpture of Nevimbumbao alone which is now on display in the Picasso Museum in Paris. Picasso was a great collector of African and Oceanian objects but their influence on him was subtle.

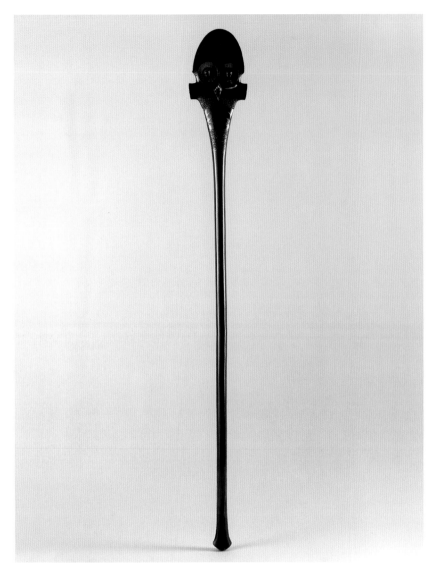

28 Club ('u'u)

Marquesas Islands, French Polynesia
Early nineteenth century
Wood. Height 145.5 cm
Donation by Michael D. and Sophie D. Coe, 1992
The Metropolitan Museum of Art, New York, USA

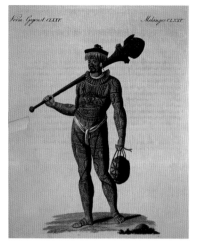

Watch out – it's not as fragile as it looks!

It looks very refined but this is actually a weapon of war – it was made for smashing heads! It is made from Toa, an extremely hard wood which is itself a warrior symbol. Known as an *'u'u* this fearsome weapon is highly prized by collectors of Oceanian art thanks to its elegant lines and dark, shiny patina (obtained with coconut oil).

Were clubs like this easy to use?

Absolutely not! They are heavy (up to five kilograms) and tall (this one is nearly one and a half metres). They were used during hand to hand combat to hit the enemy using the dangerously sharp edges. The exact size of the *'u'u* would depend on the warrior as he'd need to be able to carry it under his arm. Clubs are common throughout Polynesia but only the ones that are this large and that include figurative designs come from the Marquesas Islands (like this one does).

There are some googly eyes at the top of the stick!

Children will probably notice a little man with a big moustache and a small round nose. When you look closely you see that the pupils of the two large eyes are themselves faces and that what appears to be a nose is in fact another face with arms and hands resting on the stomach. Elsewhere you can also spot round eyes and nostrils carved in relief; above the main face's eyebrows, in profile on each temple, and finally in the middle of the designs under the 'moustache' over the handle. Marquesan clubs may appear similar at first glance but they are all subtly different.

Why include so many faces?

They are all actually the same person, the *tiki*. This is the first ancestor whose name is used for statues as well as tattoos. Shrinking him like this has the effect of increasing the spiritual power of the club's owner. Whether he is represented in full or, as here, by numerous little faces, the *tiki* is always recognizable from his large, exaggerated eyes, mouth and nostrils. His eyes convey his supernatural

ability to be all-seeing and his well-defined nostrils represent the breath of life. The largest *tikis* could measure up to three metres tall and they would hold the spirits of ancestors. Smaller *tikis* – bone earrings for example – might only be a few centimetres in size.

◊◊◊

What do the designs on the handle mean?
The interlaced curves and spirals carved in relief here are the same designs as were used for tattoos. Tattooing was outlawed by the missionaries who saw it as pagan wantonness but is now popular again following a cultural renaissance in the 1980s. Tattoos would be added throughout one's life to mark social status or significant occasions like the birth of a child. They also provided protection from evil spells. In amongst designs which were primarily for decoration were spiritual symbols. Here the faces hidden among a tangle of motifs probably hold as much meaning on a club as they would do on a human body.

Did every Marquesan have a club like this?
No. These were status symbols reserved for chiefs and warriors. Nineteenth-century drawings by westerners (like the one on the previous page) show the Marquesans with tattoos, clubs and jewellery. Combining beauty with symbolism and usefulness, the 'u'u would be made by recognized craftsmen and personalized to reflect the owner's standing.

Was war frequent between these Pacific islands?
Yes, conflict was one of the fundamentals of Polynesian societies. In the Marquesas Islands young men were trained from adolescence to be warriors, learning how to take prisoners for the human sacrifices their religion demanded. Based on provocation, the fighting could be real or simulated and would stop at the first injury or when the first prisoner was taken. Truces would be organized to coincide with significant intertribal festivals. However, when westerners introduced firearms these conflicts became much more deadly.

Why do the Marquesas have the reputation of being a peaceful paradise to us?

This image dates back to the seventeenth century when the voyager Louis Antoine de Bougainville believed that he had actually found paradise on earth. The myth was perpetuated by Paul Gauguin who fled industrialized Europe in search of 'authenticity' for Tahiti and then the Marquesas in 1901. And yet, in this land ostensibly free from the influence of 'civilisation', the Polynesians dressed in European style and prayed in the Catholic Church! Their culture had in fact disappeared with the foundation of western religious and social institutions and thanks to illnesses like tuberculosis and syphilis the population itself had also nearly disappeared (falling from 40,000 to around 2,000 in only a few decades). Gauguin painted the dream rather than the reality, yet in the popular western imagination his paintings portray life as it was lived in the Marquesas at the beginning of the twentieth century.

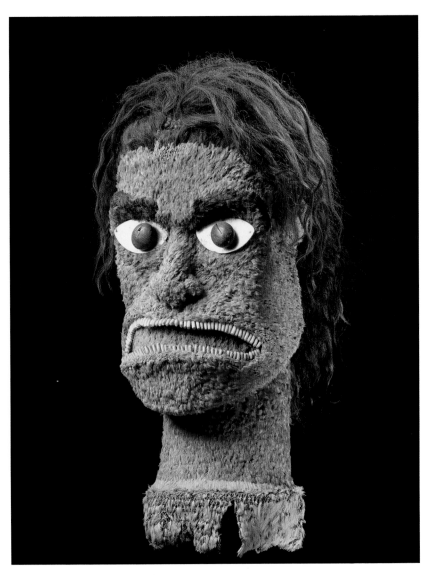

29 Hawaiian feathered head

USA
Wickerwork, feathers, hair, dog teeth, mother of pearl, wood. Height 62 cm
Collected during Cook's third voyage 1776–80
Anc. coll. du Musée Leverian
Museum für Völkerkunde, Berlin-Dahlem, Germany

It looks like a cartoon character!
Hawaiian art is so inventive and expressive that children are more likely to be enchanted by how full of character this head seems than to find him strange.

He's covered in feathers!
Yes. Like many Polynesians the Hawaiians believed their gods to be covered in down, like birds. Men had hair, the gods had feathers. Feather art is present throughout Polynesia and reached levels of high sophistication in Hawaii. Objects covered in feathers like this one were regarded as sacred (*tapu*) and the red and yellow colours here represented the divine.

How did they get hold of enough feathers?
Apparently the Hawaiians used to capture live birds by putting a kind of glue onto tree branches. After having taken the feathers they required, they would then set the birds free. The red and black feathers (on the eyebrows) come from a treecreeper. The yellow feathers (at the base of the head) are found in very small numbers on the tail and thorax of a black-coloured bird. Rare and precious, these yellow feathers were sometimes used to cover hats, capes and coats. A feather coat of this kind would need about half a million feathers from some eighty thousand birds!

What gnashers! Are they dogs' teeth?
Yes! There are nearly a hundred! Polynesians would use all sorts of natural materials, including human teeth, in their art. Teeth are among the oldest materials used by man as, like bone, they don't deteriorate easily. Whenever the Polynesians migrated by boat to new islands they would take their pigs, chickens and dogs with them. So, around the year AD 500 when the first Hawaiians arrived in the archipelago from the Society Islands or the Marquesas Islands, in addition to vegetables (seeds and coconuts) and tubers (yam and sweet potatoes) they had domestic animals, meaning they were able to survive in a terrain whose flora and fauna were relatively poor.

That mouth really is amazing!

All Hawaiian sculptures of people – whether they are made of feathers or wood – have these characteristic mouths. Despite what you might think, this is actually a kindly expression compared to the ones worn by some other feathered heads. Some have a crest of feathers on their heads (instead of hair like this one), and a more contemptuous expression, with the chin lifted and wider mouths whose corners reach right round to the ears.

How was this sculpture made?

The base is made of wicker, like a basket, and covered in a fibre net to which hundreds of small feathers are attached. The eyes are made of mother of pearl with wooden pupils. The hair is real human hair, which in Polynesia reveals the *mana* or the power of the gods; the divine strength that comes from the ancestors.

◊◊◊

Could you play games with the head to frighten people?

Oh no! This is a sacred sculpture representing a god, and playing with it would be disrespectful. These were precious objects in the eighteenth century due to their spiritual significance, the work that went into them and the scarcity of the materials used. Feathered heads, like the chiefs who owned them, were surrounded by taboos. In Polynesia works of art were the expression of the ancestors' spiritual power (*mana*). They were mainly made for elite families who themselves held the *mana* of social and political power.

Do we know which god it is?

The explorers who brought feathered heads back with them knew they represented gods but did not understand or remember which ones, and as the Hawaiian religion was abandoned early in the nineteenth century, it isn't possible to say with any certainty which god this is. It may be Lono (the god of peace, agriculture and fertility) because Lono's priests would also wear this kind of hair. Or it may be Ku (the god of war) who is represented in a similar way but with a more violent expression – a more exaggerated mouth and a feathered helmet like the ones worn by soldiers. These two gods were the only two accessible to humans and form a pair full of contradictions.

How was this head used?

No doubt it was carried during processions whenever the king travelled for ritual purposes or for war. Apparently when Captain Cook arrived in Hawaii (during his third voyage, 1768–80) the chief of the island brought heads like this to greet him. Cook was one of the first westerners to visit Hawaii and was treated with great respect. He believed that he was being accorded a welcome ceremony but the islanders may have believed him to be Lono himself as his arrival coincided with an event they were waiting for. When he came to leave the island a storm forced Cook to turn back. Unfortunately his return was taken to be sacrilege as local beliefs held that Lono would only appear again after many years. As a result Cook was stabbed on 14 February 1779. This feathered head was among some two thousand objects that were brought back from Cook's journeys to the Pacific.

◊◊◊

Are there feathered heads on all the Polynesian islands?

No, these ones are instantly recognizable as Hawaiian. Despite many similarities between the Polynesian cultures, each island or archipelago has its own distinctive characteristics. But more or less the same language is spoken throughout Polynesia and the gods are roughly the same; Ku and Lono in Hawaii correspond to Tu and Rongo in other Polynesian islands. In Melanesia however, the cultural differences between islands are very significant.

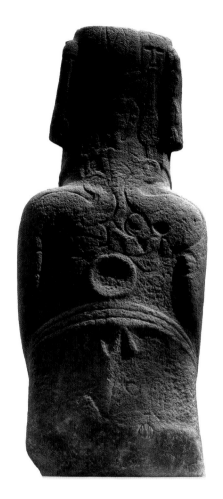
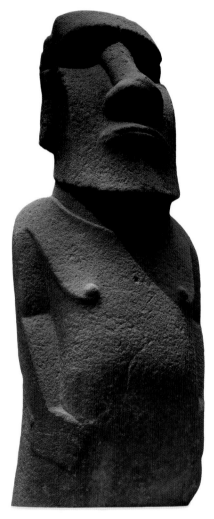

30 Easter Island moai

Hoa Hakananai'a (stolen or hidden friend)
Orongo, Rapanui (Easter Island), Chile
Probably around 1500
Basalt. Height 224 cm
Collected by the crew of the *Topaze*, 1868
Gift from Queen Victoria to the British Museum
The British Museum, London, England

He's standing to attention
Yes. He strikes an imposing, rigid figure with his arms by his sides, his prominent, pinched lips, his jutting chin and his strong, square jaw. Nearly one thousand of this kind of monolithic statue are to be found on Easter Island. They are known as *moai* and date from between AD 1000 and 1600. The inhabitants of the Island, the Rapanui people, named him *Hoa Hakananai'a* – stolen or hidden friend – perhaps out of contempt for the British sailors who took him in 1868.

This *moai* has lost his eyes!
Yes, the dark sockets give him a sombre look. Originally his gaze was a huge spiritual force, giving life to the statue – like the other *moai* the whites of his eyes were made of coral or bone and the pupil formed from *tuf* (red volcanic rock).

Why are his ears so long?
His ears are actually in proportion! It seems that Rapanui aristocrats used to pierce their ears and wear ornaments as large as shark vertebrae in them. The lobes would be irreversibly stretched by the weight of these ornaments, often down almost as far as their chins. Much as other peoples used shells, flowers, jewellery, body painting or tattoos this was probably to mark their social status.

◊◊◊

This statue is enormous!
Yes, and this one is probably missing his hat-shaped *tuf* topknot – most of the other *moai* have one. Though it's over two metres tall and weighs about four tonnes, this is one of the smaller statues to be found on the island; many of them measure up to five metres. The *moai* were generally sculpted out of *tuf* from the volcano Rano Raraku, and *Hoa Hakananai'a* is one of only ten to be made of basalt. Today's visitors to Easter Island can see restored and re-erected *moai* and also some four hundred unfinished *moai* still in their original quarry. The largest of these is twenty metres tall!

How could they move such huge rocks?

We still don't know for sure. It was originally thought that no trees were able to grow on the island and people wondered how such monolithic statues could have been transported and erected without tools for leverage. But then archaeological research showed that trees had in fact grown on the island, allowing the Rapanui people to build log sledges. So contrary to some theories these statues were neither created by people from the lost kingdom of Atlantis nor were they deposited there by martians!

Easter Island? Why not Christmas Island?

The island was discovered by the Dutch explorer Jacob Roggeveen on Easter Sunday 1722. Obviously the inhabitants didn't call it that – they called it Rapa Nui or Great Rapa as it resembled the island of Rapa in the Austral Islands of French Polynesia.

Where is Easter Island?

Easter Island is one of the most isolated islands on the planet. Fourteen miles long and seven miles wide it lies in the far eastern Pacific Ocean. Its closest neighbours are the Gambier Islands 1,500 miles away and Chile which is 2,600 miles away! According to linguists who have studied the Rapanui language, the first inhabitants probably arrived by dug-out canoe from central Polynesia between the years AD 500 and 1000.

What is the significance of the *moai*?

It is believed that the statues either commemorated gods or the ancestors of the family group whose descendants they protected, or alternatively they represented high ranking people who had been deified. The statues played a central role in funeral and initiation ceremonies during which they would become sacred.

Where were they placed?

Standing on their plinths, the *moai* were lined up on sacred ceremonial altars known as *ahu*. These platforms could extend up to fifty metres in length, and would include walkways for ritual activities beneath some of which have been found human graves. It would have required an enormous amount of work. The *ahu* sites all overlook the ocean but the *moai* face their villages inland with their backs to the sea. It seems that the number of *moai* present at an *ahu* (up to fifteen) corresponded to the importance of the family owning it. Strangely, *Hoa Hakananai'a* wasn't found at an *ahu* but in a stone house, where he was buried up to his shoulders with his back to the door.

When did the Rapanui stop honouring the *moai*?

When Europeans discovered Easter Island in 1722 some of the *moai* had already tumbled down, probably as a result of earthquakes or even vandalism during inter-tribal conflicts. It is thought that a surge in population led to the forests being over-exploited, which in turn meant the soil became less fertile and subject to erosion by storms, which further destroyed the trees. Without trees the Rapanui were unable to transport any new statues – neither were they able to make dugouts with which to leave the island.

From around 1500 a religion based on the worship of a bird-man gradually began to replace the worship of the *moai* (as a matter of fact, *Hoa Hakananai'a* has bird-man designs carved on his back). The nineteenth century brought the deportation of Rapanui people to Peru to work the guano mines, epidemics and forced labour at the hands of western adventurers. Traditional beliefs were abandoned in favour of Christianity. These shocks caused the population to shrink once again from some ten thousand in 1722 to only around a hundred in 1870, and as a result the Easter Islanders' culture was lost – even their system of writing (*rongorongo*) was forgotten.

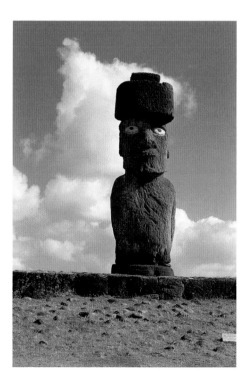

Further Information

We have marked each of the recommended sources with a symbol to denote the subject covered:

◆ – generalist
▲ – Africa
■ – Americas
▶ – Asia
● – Oceania

The suggested texts have been chosen with both quality and price in mind and each contains its own further references.

As long as they are of a length appropriate to your children, we also recommend visits to archaeological and historical sites like the Mayan pyramids in Mexico and Guatemala, the Abomey Palace in Benin or the Uluru-Kata Tjuta National Park (Ayers Rock) in Australia. Shows, including Indonesian puppet theatre, are also a great way of introducing your children to world art during holidays abroad.

Cinema, theatre, music, dance and cooking are often favourites with children and they offer a great way of encountering *otherness*. Other indispensible teaching aids include exhibitions (permanent or temporary in museums, galleries or auction rooms), books, audiovisual and multi-media productions – the internet, CDs, DVDs and documentaries. Here is a short selection:

Travel writing

■ *History of a Voyage to the Land of Brazil* by Jean De Lery, University of California Press
■ *Tristes Tropiques* by Claude Levi-Strauss, Penguin
■ *Argonauts of the Western Pacific* by Bronislaw Malinowski, Waveland Press
▶ *Not a Hazardous Sport* by Nigel Barley, Penguin
▶ *My Journey to Lhasa* by Alexandra David-Neel, Virago Press
● *The Songlines* by Bruce Chatwin, Vintage

● *James Cook and the Exploration of the Pacific* by Adrienne L. Kaeppler and Robert Fleck, Thames & Hudson

Essays

◆ *Black Skin, White Masks* by Frantz Fanon, Pluto Press
◆ *Primitive Art in Civilized Places* by Sally Price, University of Chicago Press

Fiction for adults

◆ *The Spirit of the Laws* by Charles de Montesquieu, Cambridge University Press
◆ *Candide* by Voltaire, Penguin Popular Classics
▲ *Waiting for the Wild Beasts to Vote* by Ahmadou Kourouma, Vintage
▲ *The Dark Child: The Autobiography of an African Boy* by Camara Laye, Farrar Straus Giroux
▲ *Ake: The Years of Childhood* by Wole Soyinka, Methuen
■ *Black Like Me* by John Howard Griffin, Penguin
▶ *East Wind, West Wind: The Saga of a Chinese Family* by Pearl S. Buck, Moyer Bell
▶ *The Girl Who Played Go* by Shan Sa, Vintage

Illustrated books for adults

◆ *Primal Arts volumes 1 and 2* by Berenice Geoffroy-Schneiter, Assouline
◆ *The Dictionary of Art in 34 volumes* edited by Jane Turner, Grove/ Macmillan
▲ *Contemporary African Art* (World of Art series) by Sidney Littlefield Kasfir, Thames & Hudson
▲ *African Art* (World of Art series) by Frank Willett, Thames & Hudson
■ *Native Arts of North America* (World of Art series) by Christian F. Feest, Thames & Hudson
■ *The Art of Mesoamerica (*World of Art series) by Mary Ellen Miller, Thames & Hudson
▶ *Messages in Stone: Statues and Sculptures from Tribal Indonesia in the Collections of the Barbier-Mueller Museum* by Alain Viaro and Arlette Ziegler, Skira

● *Art Of The Pacific* (Everyman Art Library) by Anne D'Alleva, Weidenfeld & Nicolson
● *Oceanic Art* (World of Art series) by Nicholas Thomas, Thames & Hudson

Illustrated books for children
■ *Yakari* series of comic strips by Derib and Job, Cinebook
■ *The Aztec and Maya Worlds* (Step Into series) by Fiona MacDonald, Southwater

Journals for adults
◆ Tribal Art Magazine
▲ African Arts

Websites
www.thebritishmuseum.ac.uk
www.civilisations.ca
www.metmuseum.org
www.oceanie.org
www.prm.ox.ac.uk
www.quaibranly.fr

Documentary films
▲ *Darwin's nightmare*, Hubert Sauper
■ *Nanook of the North*, Robert Flaherty
● *Them and Me*, Stephane Breton

Films for adults
▲ *The Gods Must be Crazy*, Jamie Uys
▲ *Out of Africa*, Sydney Pollack
▲ *Yaaba*, Idrissa Ouedraogo
▲ *Yeelen*, Souleymane Cissé
■ *Aguirre the Wrath of God*, Werner Herzog
■ *Buena Vista Social Club*, Wim Wenders
■ *Dances With Wolves*, Kevin Costner
■ *The Last Trapper*, Nicolas Vanier
■ *The Emerald Forest*, John Boorman
■ *Little Big Man*, Arthur Penn
■ *The Mission*, Roland Joffe
▶ *The Cave of the Yellow Dog*, Byambasurem Davaa
▶ *The Last Samurai*, Edward Zwick
▶ *Dersu Uzala*, Akira Kurosawa
▶ *Himalaya*, Eric Valli
● *Once Were Warriors*, Lee Tamahori

Films for children
▲ *Kirikou*, Michel Ocelot
■ *Pocahontas*, Mike Gabriel and Eric Goldberg
▶ *Mulan*, Barry Cook and Tony Bandcroft

Museums
Austria – Museum für Völkerkunde (Vienna)
Belgium – Musée Royal de l'Afrique Central (Tervuren near Brussels)
Canada – Musée canadien des civilisations (Hull, Quebec), Museum of Anthropology (Vancouver, BC)
Columbia – Museo del oro (Bogota)
France – Musée du quai Branly (Paris), Fondation Dapper (Paris), Musée des Arts Africains Océaniens et Amérindiens (Marseille), Centre Culturel Tijbaou (Noumea, New Caledonia)
Germany – Ethnologishes Museum (Berlin-Dahlem)
Italy – Museo Nazionale Preistorico Etnografico Luigi Pigorini (Rome)
Japan – National Museum (Tokyo)
Mali – National Museum (Bamako)
Mexico – Museo nacional de antropologica (Mexico City)
Netherlands – Tropenmuseum (Amsterdam), Rijksmuseum voor Volkenkunde (Leyde)
Spain – Museum Barbier-Mueller d'Art Precolombien (Barcelona)
Switzerland – Musée Barbier-Mueller (Geneva), Museum de Kulturen (Basle), Museum Rietberg (Zurich)
UK – The British Museum (London), Pitt Rivers Museum (Oxford)
USA – The Metropolitan Museum of Art (New York), National Museum of the American Indian George Gustave Heye Centre (New York), Smithsonian Institution (Washington DC)
Vanuatu – Centre Culturel (Port Vila)

Acknowledgements

The Publishers would like to thank Jeremy Coote, joint Head of Collections, Pitt Rivers Museum, Oxford.

Photographic acknowledgements

Akg-images, Paris: 70 (© Werner Forman), 86 (© CDA)/Guillemot), 98 (© Werner Forman), 162
BPK, Berlin, Dist RMN: 166 (unknown photographer)
The Bridgeman Art Library, Paris: 66
The British Museum, London: 170
Denver Art Museum, Denver: 58
Gemeente Musea Delft, Museum Nusantara, 138
The Metropolitan Museum of Art, New York, 54, 90, 162, 82 (© Ramon Sarró), 170 (© Pierre Hamaide)
Musée des Arts Africains Océaniens et Amérindiens, Marseille: 78 (© Gérard Bonnet)
Musée des Arts Asiatiques (Conseil Général des Alpes Maritimes), Nice: 126
Musée Barbier-Mueller, Geneva: 82, 154 (© abm-images, Barbier-Mueller archives, Studio Ferrazzini-Bouchet, Geneva), 134 (©Studio Ferrazzini-Bouchet, Geneva, previously collection of Barbier-Mueller, Musée du quai Branly)
Musée international du carnaval et du masque, Binche: 122
Musée Royal de l'Afrique Central, Tervuren: 118
Museo del oro, Bogota: 74
Museum de Kulturen, Basle: 150
Museum images: 110
National Museum, Tokyo: 130
National Museum of African Art, Smithsonian Institution: 114 (© Franko-Khoury)
National Museum of the American Indian, New York: 62
RMN, Paris: 94 (© Jean-Gilles Berizzi/Thierry Le Mage), 102 (©Erik Hesmerg), 106 (©Philippe Migeat), 146 (© rights reserved), 158 (©Daniel Arnaudet)
Staatliches Museum für Völkerkunde, Munich, 142